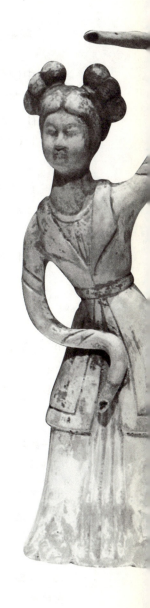

英汉对照

中国名歌选萃

Selected Well-known Chinese Songs

杜亚雄/编著
杜亚琛/译

Written by Du Yaxiong
Translated by Du Yachen

苏州大学出版社
Soochow University Press

图书在版编目（CIP）数据

中国名歌选萃＝Selected Well-known Chinese Songs：英汉对照 / 杜亚雄编著；杜亚琛译.--苏州：苏州大学出版社，2019.7
ISBN 978-7-5672-2431-5

Ⅰ.①中⋯ Ⅱ.①杜⋯ ②杜⋯ Ⅲ.①歌曲—中国—选集—英、汉 Ⅳ.①J642

中国版本图书馆CIP数据核字（2018）第270668号

书　　名：	中国名歌选萃 Selected Well-known Chinese Songs （英汉对照）
编　　著：	杜亚雄
译　　者：	杜亚琛
责任编辑：	王　娅
装帧设计：	吴　钰
出版发行：	苏州大学出版社（Soochow University Press）
社　　址：	苏州市十梓街1号　邮编：215006
网　　址：	www.sudapress.com
E - mail：	sdcbs@suda.edu.cn
印　　刷：	苏州工业园区美柯乐制版印务有限责任公司

邮购热线：0512-67480030　　销售热线：0512-67481020
网店地址：https://szdxcbs.tmall.com/ （天猫旗舰店）

开　　本：	700mm×1000mm　1/16　印张：18.25　字数：229千
版　　次：	2019年7月第1版
印　　次：	2019年7月第1次印刷
书　　号：	ISBN 978-7-5672-2431-5
定　　价：	59.00元

凡购本社图书发现印装错误，请与本社联系调换。
服务热线：0512-67481020

中国名歌选萃
Selected Well-known Chinese Songs

目 录
Contents

古代歌曲（5首）

1. 关雎（抒情歌曲　诗经词　宋代传乐谱）　/003

2. 胡笳十八拍（叙事歌曲　汉　蔡文姬词、曲）　/013

3. 阳关三叠（琴歌　唐　王维词）　/045

4. 杏花天影（艺术歌曲　宋　姜夔词、曲）　/059

5. 满江红（古曲　宋　岳飞词）　/069

民歌（10首）

6. 茉莉花（江苏民歌）　/079

7. 康定情歌（四川民歌）　/089

8. 小河淌水（云南民歌）　/097

9. 在那遥远的地方（哈萨克族民歌　王洛宾改编）　/105

10. 达坂城的姑娘（维吾尔族民歌　王洛宾改编）　/115

11. 乌苏里船歌（赫哲族民歌　汪云才、郭颂改编）　/121

12. 龙船调（土家族民歌）　/129

13. 花儿为什么这样红（塔吉克族民歌　雷振邦改编）　/137

14. 敖包相会（蒙古族民歌　通福改编）　/143

15. 宗巴郎松（藏族民歌）　/149

Selected Well-known Chinese Songs
Contents

Songs from Ancient Times (Five Pieces)

1. The Turtle Dove /003
(A lyrical song, lyrics from *The Book of Songs*, music from scores passed down from the Song Dynasty 960–1279)

2. Eighteen Pos of *Hujia* /013
(A narrative song, lyrics and music by Cai Wenji of the Han Dynasty 206 BC–220 AD)

3. Three Variations of a Farewell Song at Yang Pass /045
(A qin song, lyrics by Wang Wei in the Tang Dynasty 618–907)

4. Apricot Blossoms Against the Sky /059
(An art song, lyrics and music by Jiang Kui of the Song Dynasty 960–1279)

5. Manjianghong (Azolla) /069
(An ancient melody, lyrics by Yue Fei of the Song Dynasty 960–1279)

Folk Songs (Ten Pieces)

6. Jasmine /079
(A folk song of Jiangsu Province)

7. Kangding Love Song /089
(A folk song of Sichuan Province)

8. Bubbling Brook /097
(A folk song of Yunnan Province)

9. In a Distant Land /105
(A Kazak folk song, adapted by Wang Loubin)

10. The Girl from Dabancheng /115
(A Uygur folk song, adapted by Wang Luobin)

11. Ussuri River Shanty /121
(A Hezhen folk song, adapted by Wang Yuncai and Guo Song)

12. A Dragon Boat Tune /129
(A *Tujia* folk song)

13. Why Is the Flower So Red /137
(A Tajik folk song, adapted by Lei Zhenbang)

14. Rendezvous at an Obo /143
(A Mongolian folk song, adapted by Tongfu)

15. Zongba Langsong /149
(A Tibetan folk song)

20世纪创作歌曲（15首）

16. 教我如何不想她（刘半农词　赵元任曲）　/161

17. 渔光曲（安娥词　任光曲）　/169

18. 义勇军进行曲（田汉词　聂耳曲）　/177

19. 二月里来（塞克词　冼星海曲）　/185

20. 歌唱祖国（王莘词、曲）　/193

21. 我的祖国（乔羽词　刘炽曲）　/201

22. 让我们荡起双桨（乔羽词　刘炽曲）　/209

23. 我爱你，中国（瞿琮词　郑秋枫曲）　/217

24. 美丽的草原我的家（火华词　阿拉腾奥勒曲）　/225

25. 草原之夜（张加毅词　田歌曲）　/231

26. 在希望的田野上（陈晓光词　施光南曲）　/237

27. 小城故事（庄奴词　翁清溪曲）　/243

28. 青藏高原（张千一词、曲）　/251

29. 阿里山的姑娘（邓禹平词　张彻曲）　/259

30. 走进新时代（蒋开儒词　印青曲）　/267

Songs Created in the 20th Century (Fifteen Pieces)

16. How Could I Not Miss Her /161
(Lyrics by Liu Bannong, music by Zhao Yuanren)

17. A Fishermen's Song /169
(Lyrics by An E, music by Ren Guang)

18. March of the Volunteers /177
(Lyrics by Tian Han, music by Nie Er)

19. In February /185
(Lyrics by Saike, music by Xian Xinghai)

20. Ode to the Motherland /193
(Lyrics and music by Wang Xin)

21. My Motherland /201
(Lyrics by Qiao Yu, music by Liu Chi)

22. Let's Row with a Pair of Oars /209
(Lyrics by Qiao Yu, music by Liu Chi)

23. I Love You, China /217
(Lyrics by Qu Cong, music by Zheng Qiufeng)

24. Beautiful Grassland My Home /225
(Lyrics by Huohua, music by Alteng Aole)

25. A Night in the Prairie /231
(Lyrics by Zhang Jiayi, music by Tian Ge)

26. In Promising Fields /237
(Lyrics by Chen Xiaoguang, music by Shi Guangnan)

27. The Story of a Small Town /243
(Lyrics by Zhuang Nu, music by Weng Qingxi)

28. The Tibetan Plateau /251
(Lyrics and music by Zhang Qianyi)

29. Girls Living in the Alishan Mountain /259
(Lyrics by Deng Yuping, music by Zhang Che)

30. Entering a New Era /267
(Lyrics by Jiang Kairu, music by Yin Qing)

中国名歌选萃
Selected Well-known Chinese Songs

前 言

Preface

中国是一个拥有960万平方公里陆地国土面积、具有5 000多年文明史的国家。56个民族的人民生活在这片辽阔的土地上，创造了古老的文明和灿烂的文化。

中国的东面和南面有一望无际的大海，北面有荒漠和草原，西部是号称世界屋脊的青藏高原。在遥远的古代，这样的地理环境影响了中国人和世界其他地区与民族的交流。然而，我们的祖先仍然克服艰难险阻，穿越无人居住的沙漠和瀚海，跨过高耸入云的雪山和冰川，开辟出了绿洲丝绸之路和草原丝绸之路，同时在辽阔的海洋上开辟了海上丝绸之路，把中国和中亚、南亚乃至欧洲和非洲连接起来。多条丝绸之路的开辟证明两千多年前，中国人就有和世界上其他文明进行交流，加强了解，互通有无，共同进步的强烈愿望。在其后的历史发展过程中，中国各族人民一直保持了这一优秀传统，20世纪70年代末之后，它更得到了发扬和光大。

伊斯兰教的先知穆罕默德曾经说过："哪怕知识远在中国，也要往而求之。"可见，在那个时代，从中、近东地区到中国来都不是一件容易的事情。威尼斯商人马可·波罗的游记在欧洲引起的反响也说明，直到13、14世纪，欧洲还很少有人到中国来，欧洲人也不怎么了解中国和中国文化。

Selected Well-known Chinese Songs
Preface

Considered one of the cradles of human civilizations, with an land area of 9,600,000 square kilometers and a 5,000-year history, China is the longest continuous civilization in the world. On this vast land live 56 ethnic groups who have created this splendid culture over thousands of years.

In ancient times, the communication between Chinese people and other parts of the world was constrained by the country's geography: endless oceans to the east and south, deserts and grassland in the north, while there is the rugged Qinghai-Tibet Plateau called "the roof of the world". However, our ancestors were not daunted by difficulties or dangers. Toiling across the uninhabited desert and vast seas, struggling over sky scraping snowy mountains and glaciers, they established the oasis Silk Road, steppe Silk Road and maritime Silk Road that connected China with Central Asia, South Asia, Europe, and even Africa. As early as two thousand years ago, this demonstrated that Chinese people were willing to communicate, to trade and to interact with other civilizations, and to understand other cultures. Chinese people have been following this tradition throughout history, especially after 1970s.

Mohammed, the Islamic prophet, said, "We should seek knowledge, even if we have to go as far as to China." This comment shows that in those days it was not easy to reach China from the Middle East and the Near East. The popularity of the book, *The Travels of Marco Polo*, recounting the travels of the famous Venetian merchant, indicates that until the 13th and 14th centuries China had been an unfamiliar land of mysteries for the Europeans. Because few had visited China, the Europeans had no knowledge of this country and her culture.

这一情况到近现代有了很大的改观，但由于种种不同的原因，世界其他地区对中国人和中国文化的了解还是远远不够的。有人做过统计，20世纪中国翻译出版了欧美的数十万种著作，而中文著作被翻译成外文出版的只有区区数百种而已。之所以出现这种不平衡的情况，除其他原因外，中国语言文字的特殊性是一个很重要的因素。

儒家经典《乐记》中说："凡音之起，由人心生也。"音乐是全世界各个民族都拥有的、发自心灵深处的、最能表达人类思想情感的一种语言。由于各种文化都拥有发自内心的音乐，所以它在某种程度上具有人类共同语言的性质。儒家倡导"礼乐治国"，中国人喜欢音乐，音乐是中国文化最重要的组成部分之一，也最能表现中国人的所思所想和价值观。为了帮助大家，特别是外国朋友了解中国音乐文化和中国人的思想情感，我特别编写了《中国名歌选萃》和《中国名曲选萃》这两本书。书中包括的60首歌曲和乐曲，既有数千年前的古代作品，也有近年来的新作，既有汉族音乐，也有少数民族的作品。希望这两本书能对想了解中国音乐文化的朋友有所帮助。

本书中所选的30首歌曲是我从千万首中国歌曲中遴选出来的，我为其中的每首歌曲写了一些解释性的文字。我的妹妹杜亚琛将这些文字译成英文，我的夫人、美国芝加哥德堡大学英语学

The situation has changed greatly in modern times. Yet, for a variety of reasons, Chinese culture is still little known to people in the other parts of the world. According to some statistics, during the 20th century alone, over 100,000 works from Europe and the U.S. had been translated and published in China. However, the number of Chinese works translated and published in European languages is no more than a few hundred. One reason for this unbalanced situation is the nature of the Chinese language.

"Mundane music comes out of people's heart," says one passage of *The Record of Music*, a Confucian classic. Arising from deep of the heart, music is a language shared by every culture in the world, expressing human ideas and feelings to the fullest. To some degree, we can say that music is a common human language. Confucianism advocates ruling the country through Liyue (rite and music). Chinese people love music, one of the most important aspects of Chinese culture. It expresses not only what people feel and think, but also what people value. In order to help readers, especially foreign readers to better understand Chinese music and thinking, I have compiled two books: *Selected Well-known Chinese Songs* and *Selected Well-known Chinese Instrumental Pieces*. From hundreds of thousands of excellent Chinese music works, only 60 have been selected, including ancient pieces as well as new ones written in modern times. Some were created by Han people while others by ethnic minorities. I hope that the two books will be helpful to those interested in Chinese music culture.

From ten million Chinese songs, I selected 30 for this book, providing a short explanatory note for each. I would like to extend my heart-felt thanks to my sister, Du Yachen, for the translation, my

院教师 Izabella Horvath 审定了英译文，苏州大学出版社洪少华先生为本书的出版付出了许多心血。没有他们的努力，本书不可能出版，在此一并致谢。

用中英文对照的形式写作来介绍中国音乐的书籍，尚属首次，由于缺乏经验，恳请读者提出宝贵意见，帮助我把这项工作做得更好。

<div style="text-align:right">

杜亚雄

2017 年春节

</div>

wife, Izabella Horvath, for proofreading, and Mr. Hong Shaohua from Soochow University Press who has made painstaking efforts to prepare the work for publication. Their hard work and cooperation enable the publication of these volumes.

Since it is the first bilingual publication to introduce Chinese music, I would be very grateful for comments from my readership so as to improve the content in future editions.

<div align="right">
Du Yaxiong

Spring Festival of 2017
</div>

中国名歌选萃

Selected Well-known Chinese Songs

古代歌曲（5 首）

Songs from Ancient Times
(Five Pieces)

关 雎 ① The Turtle Dove

扫码欣赏
Scan the code to appreciate

抒情歌曲　诗经词　宋代传乐谱

A lyrical song, lyrics from *The Book of Songs*, music from scores passed down from the Song Dynasty (960–1279)

中国名歌选萃
一、古代歌曲（5首）

2 500多年前，中国进入了"春秋"时代。这个时代虽有许多战乱，但也出现了中国历史上文化建设的第一个高潮。"春秋"在学术上是一个"百家争鸣"的时代，许多伟大的学者纷纷著书立说，创立了不同的学派。这些学者中最具有代表性、对后世最有影响的是创立了儒家学派的孔子和创立了道家学派的老子。

孔子不仅是当时最著名的哲学家，同时也是我国历史上创办第一所私立学校的伟大教育家。孔子本人喜欢唱歌，而且能演奏多种乐器。他非常重视音乐课，整理了流传在民间的许多歌曲，经过筛选，编成供学生学习使用的包含305首歌曲的《诗经》一书。《诗经》中除收录了160首民歌外，还收录了一些祭祀祖先的歌和许多贵族创作的艺术歌曲。《关雎》是当时流传的一首民歌，写一个年轻小伙对一位姑娘的爱恋。孔子非常欣赏这首歌，称赞其"乐而不淫"，并且把它作为第一首歌编入《诗经》。

《关雎》首段的头两句先讲自然，后两句才讲人的情感，这种手法在我国诗歌中叫"兴"。"兴"由写景引起抒情，有时其中不含比喻，有时却与比喻有关。《关雎》的第一、二句中，"雎鸠"是鸟名，"鸟"与男根之俗名谐音，故象征男性，而"鱼"则是女阴的象征。"雎鸠"为什么在黄河边的沙洲上"关关"而鸣？为求"鱼"。第三、

Selected Well-known Chinese Songs
I. Songs from Ancient Times (Five Pieces)

The Spring and Autumn Period, fraught with wars and conflicts, lasted from 770BC to 476 BC. Despite the violent upheavals, it was the time of the first cultural boom in China's history. The Spring and Autumn Period is known as the era of the "Hundred Schools of Thoughts". At that time many great scholars wrote books, developed theories, and created different schools, among whom, the most representative and influential ones were Confucius, the founder of Confucianism and Lao Zi, the founder of Daoism.

Not only was Confucius the most renowned philosopher in his time, but he was also a great educator, founding the first private school in the history of China. He was fond of singing and could play many instruments. In his classes he stressed the importance of music education. His collection of selected songs was widely circulated. He compiled *The Book of Songs* as a textbook for his students, containing 305 songs. Besides 160 folk songs, there were songs for rituals for ancestor worship, and many art songs written by nobles. "The Turtle Dove", a popular folk song at that time, became the first piece in his book because Confucius judged it to be beautiful, not "obscene" music.

To understand the view of Confucius, we need to analyze the lyrics. In the first stanza of "The Turtle Dove", the first two lines give a description of nature, followed by that of people's feelings in the last two lines. This style is known as *xing* in Chinese poetry. Sometimes the first two lines are metaphors, other times not. The Chinese pronunciation of the word bird is *niao*. This pronunciation happens to

四句中的"窈窕淑女,君子好逑"道明了其中的含义。这个"兴"在诗人来说是如此直接,而对他人来说则非常微妙。"兴"虽然质朴,其中也有体验生命的深刻道理。

《关雎》不是实写,而是虚拟之作。接下来写年轻人"求之不得"的痛苦心情,"琴瑟友之"写他和"窈窕淑女"交往的希望,"钟鼓乐之"则是描写他梦想中与"窈窕淑女"结婚的场面。《诗经》中写男女爱情的作品,多用虚拟的手法,即所谓"所思之境",如《汉广》《月出》等篇。《关雎》是其中最为恬静温和的,有首有尾,而且有一个梦境中的完满结局。

Selected Well-known Chinese Songs
I. Songs from Ancient Times (Five Pieces)

be homophonous with the word for the male sex organ. Thus, the turtle dove in this song symbolizes a man, while in Chinese folklore, the fish is the symbol of womanhood. *Xing* here appeals to the imagination of the readers and listeners, who are familiar with the symbolic system: Why are turtle doves singing at the sandbar of the Yellow River? They are hunting for fish. What *xing* implies is clearly shown in the third and fourth lines of the stanza: A good young man is wooing for / A maiden fair he loves. The poet uses *xing* to suggest physical love. Simple and natural, the poem depicts the profound truth, the basis for the foundation and eventually the continuation of life.

Rather than telling a story directly, "The Turtle Dove" paints a scene from nature and appeals to the imagination. The stanzas describe the anguish of the young man who seeks but fails to get the heart of the girl he loves. The third and fourth lines of the third stanza, "O lute, play music bright / For the bride fair and slender" show his wishes to please the girl with music while those of the last stanza, "O bells and drums, delight /The bride so fair and slender" describe his dreams of a wedding ceremony with the girl being his bride. In *The Book of Songs*, the titles of love songs are given symbolically, such as, *The Wide Han River* and *The Moon Rise*. The actual love scenes are left to the imagination.

中国名歌选萃
一、古代歌曲（5首）

《关雎》的词意很单纯，孔子之所以把它放在《诗经》首篇，大概是因为其旋律很美。他在《论语·泰伯》一章中说过："师挚之始，《关雎》之乱，洋洋乎盈耳哉。""乱"是中国古代音乐结束时的合奏，孔子这样讲可见这首歌的结尾部分非常动听。

目前存见最早的《关雎》乐谱为宋代出版的唐代传谱，谱中所记录的可能已不是孔子时的唱法。乐谱中没有记录歌曲的节奏，只用中国古代的律吕字记录了旋律的音高。律吕是中国古代十二个音名的简称，它们分别是黄钟、大吕、太簇、夹钟、姑洗、中吕、蕤宾、林钟、夷则、南吕、无射、应钟，相当于西洋乐谱中的C、♯C、D、♯D、E、F、♯F、G、A、♭A、♭B、B 12个音。从乐谱中记录的音高来看，此歌采用七声音阶。中国人把西洋音乐中的 do, re, mi, sol, la 分别称为宫、商、角、徵、羽，这首歌的主音是 sol，按中国乐理它是徵调式。乐谱中虽然没有记录节奏，但吟诵古诗有常用的节奏形态，这首歌的节奏是合唱队的指挥根据吟诵此诗的节奏拟订的。

歌词：

关关雎鸠，

Selected Well-known Chinese Songs
I. Songs from Ancient Times (Five Pieces)

The lyrics of "The Turtle Dove" are very simple. The reason why Confucius put it at the beginning of *The Book of Songs* may also lie in the beauty of its melody. In "Taibo of the Analects", Confucius says, "The overture of music piece of Shizhi and Luan of 'The Turtle Dove' are wonderful and spectacular." *Luan* means an "ending" or a "coda" in ancient Chinese music. Therefore, the comment made by Confucius indicates that the ending of "The Turtle Dove" must be very pleasant to hear.

Based on the version passed down from the Tang Dynasty, the earliest preserved music score of "The Turtle Dove" was published in the Song Dynasty. This version is unlikely to be the same as that sung in Confucius' time. There are no rhythm marks in the notation, and it uses the so-called *lǜlǜ* characters to record the pitch of the melody. *Lǜlǜ* characters are the names given to the twelve tones: *huangzhong, dalǚ, taicu, jiazhong, guxian, zhong* lǚ, *ruibing, linzhong, yize, nanlǚ, wuyi* and *yingzhong*, equivalent to the Western C, $^\sharp$C, D, $^\sharp$D, E, F, $^\sharp$F, G, $^\flat$A, A, $^\flat$B and B. According to Chinese music theory, *gong, shang, jue, zhi, yu* scales are equivalent to Western do、re、mi、sol and la. From the pitch recorded in the score of "The Turtle Dove", the keynote of the song is in the zhi (same as Western sol) mode. Although the rhythm was not recorded, poetry reciting in China follows the more or less frequently used rhythmic forms, according to which the conductor of the chorus marked them out.

Lyrics:

By riverside are cooing

中国名歌选萃
一、古代歌曲（5首）

在河之洲。
窈窕淑女，
君子好逑。

参差荇菜，
左右流之。
窈窕淑女，
寤寐求之。

求之不得，
寤寐思服。
悠哉悠哉，
辗转反侧。

参差荇菜，
左右采之。
窈窕淑女，
琴瑟友之。

参差荇菜，
左右芼之。
窈窕淑女，
钟鼓乐之。

Selected Well-known Chinese Songs

I. Songs from Ancient Times (Five Pieces)

A pair of turtle doves;

A good young man is wooing for

A maiden fair he loves.

Water flows left and right

Of cresses here and there;

The youth yearns day and night

For the good maiden fair.

His yearning grows so strong

He cannot fall asleep;

He tosses all night long,

So deep in love, so deep!

Now gather left and right

The cresses sweet and tender;

O lute, play music bright

For the bride fair and slender!

Feast friends at left and right

On cresses cooked so tender;

O bells and drums, delight

The bride so fair and slender!

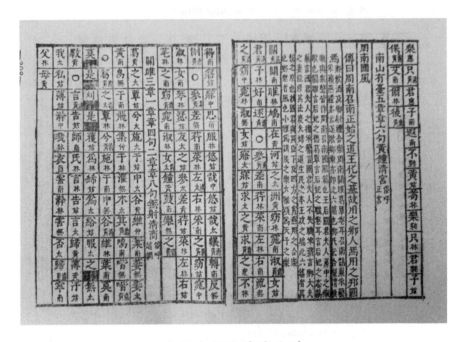

宋代出版的关雎乐谱
Music score of "The Turtle Dove" published in the Song Dynasty

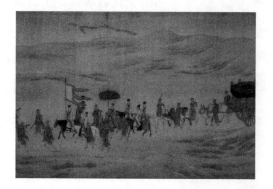

胡笳十八拍 ② Eighteen Pos of *Hujia*

扫码欣赏
Scan the code to appreciate

叙事歌曲　汉 蔡文姬词、曲

A narrative song, lyrics and music by Cai Wenji of the Han Dynasty
(206 BC–220 AD)

一、古代歌曲（5首）

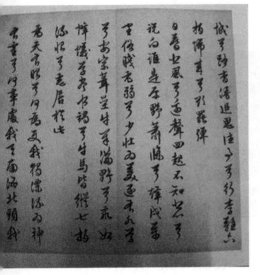

《胡笳十八拍》是我国古代最著名的长篇叙事诗，全诗有一百多行，原载于宋代郭茂倩编辑的《乐府诗集》卷五十九及朱熹《楚辞后语》卷三，两个版本中的文字略有出入。相传这首诗是东汉女诗人兼音乐家蔡文姬的作品。

蔡文姬（177年—？），名琰，其父是文学家、音乐家、书法家蔡邕。蔡邕是东汉首都洛阳的文坛领袖之一，曹操是他的好友。蔡文姬受家庭影响，自小耳濡目染，博学多才、擅长诗赋、精通音律、琴艺超人。

蔡文姬16岁时嫁给卫仲道，可惜婚后不到一年，丈夫因病去世，她又在战乱中被匈奴人掠去，被左贤王纳为王妃。蔡文姬在南匈奴住了12年，学会了匈奴的音乐，并育有两子。建安十三年（208年），曹操得知她流落南匈奴，便派使者携黄金千两、白璧一双，把她赎回汉朝。

Selected Well-known Chinese Songs

I. Songs from Ancient Times (Five Pieces)

"Eighteen Pos of *Hujia*" is one of the most renowned narrative poems from ancient China with over one hundred lines of lyrics. The oldest version is from the Song Dynasty (960–1279), in volume 59 from a work called *Collection of Yuefu Poems* edited by Guo Maoqian. A later version comes from volume 3 of *Study on the Songs of Chu* written by Zhu Xi in the Southern Song Dynasty (1127–1279). The two versions have but slight differences. It is said that Cai Wenji, a female poet and musician who lived during the Eastern Han Dynasty (25–220), was the composer.

Her given name being Yan, Cai Wenji (177–?) was the daughter of Cai Yong, a literati, musician, and calligrapher in the Eastern Han Dynasty. An intimate friend of Cao Cao (powerful chancellor of the Han Emperor), Yong was one of the leaders in the literary circle in Luoyang, the capital of the Eastern Han Dynasty. Wenji was brought up in such a stimulating environment, and was known to be learned, witty, a talented poet who was also a skilled qin-player.

At 16, Cai Wenji married Wei Zhongdao. The marriage ended with the death of her husband in less than a year. Along with a number of Han princesses, she became a prisoner of war, and Zuoxian, the king of the Huns, held her as hostage. She lived in the southern Hun territory for 12 years and gave birth to two sons. She also learned Hun music. It was not until the year of 208 that she returned to Han with the help of her father's friend, Cao Cao, who discovered her whereabouts. Cao Cao sent an envoy with a thousand *liang* of gold and a pair of precious white jade ornaments as ransom.

一、古代歌曲（5首）

胡笳是古代匈奴人的乐器，十八拍即十八段，《胡笳十八拍》的曲调见于1611年刊行的《琴适》一书，它展现了蔡文姬从匈奴回归途中的所思所想，倾诉了她被掳、思乡、别子、归汉等一系列坎坷的遭遇，反映了她在战乱之中的悲欢离合之情，具有很强的艺术感染力。

《胡笳十八拍》采用叙事性写法，音乐随十八段词的情绪变化改变陈述方式，其中不乏悲凉和激动，更充满了戏剧性。《胡笳十八拍》的曲调，传说是蔡文姬根据匈奴乐器胡笳的旋律创作的。胡笳的音色尚悲，擅长奏哀怨之声，蔡文姬选用胡笳的音调作《胡笳十八拍》，可谓独具匠心。

《胡笳十八拍》的第一拍即点出"乱离"的背景：胡虏强盛、烽火遍野、民卒流亡。汉末天下大乱，宦官、军阀相继把持朝政，农民起义、军阀混战、外族入侵，陆续不断。蔡文姬在兵荒马乱之中被胡骑掠去。

Selected Well-known Chinese Songs

I. Songs from Ancient Times (Five Pieces)

A *hujia* is an ancient Hun wind instrument. Eighteen pos means "eighteen stanzas". The music of "Eighteen Pos of *Hujia*" is found in *Qinshi*, a score book printed in 1611. The work is a narrative of Wenji's thoughts and feelings composed while returning to Han. She poured out all the bitterness of the misfortunes that had befallen her: her captivity, homesickness, and the eventual forced departure from her two sons, as well as the joy of returning home. Being the expression of mixed feelings of sorrow and happiness, "Eighteen Pos of *Hujia*" has a strong artistic and emotional appeal.

"Eighteen Pos of *Hujia*" is a narrative work. The style alternates according to the change of emotion from stanza to stanza. It is believed that Wenji composed the music according to a melody of the *hujia*. The sad tone of the *hujia* is well suited for playing sentimental and melancholy tunes. Choosing a Hun melody for "Eighteen Pos of *Hujia*" illustrates Wenji's yearning for her children as a mother, as well as her artistic sensibility and ingenuity as a composer.

The first po of "Eighteen Pos of *Hujia*" paints the background of the horrors of war and the resulting forced exile of thousands of people. The Huns were gaining power, and there were battles everywhere. People fled as a result of incessant peasant uprisings, continuous power struggles among warlords, and non-stop foreign invasions. The country fell into chaos, and eunuchs and warlords fought for power. In the turmoil, Wenji was captured by the Hun cavalry.

被掳，是她痛苦生涯的开端，也是她痛苦生涯的根源，因而诗中专用第二拍写她在被掳途中的情况，又在第十拍中用"一生辛苦兮缘别离"，点明一生的不幸源于被掳。她在南匈奴期间，生活上和精神上都承受着巨大的痛苦。她既无法适应塞外恶劣的自然环境，也不能忍受匈奴人与汉族迥异的生活习惯，因此唱出了"殊俗心异兮身难处，嗜欲不同兮谁可与语"的痛苦心声，而令她最为不堪的，还是在精神方面。

在精神上，她承受着双重的屈辱：作为汉人，她成了匈奴人的俘虏；作为女人，她被迫嫁给了匈奴人。第一拍所谓"志意乖兮节义亏"，其内涵正是相对于这双重屈辱而言的。在身心两方面都受到煎熬的情况下，思念故国、思返故乡，就成了支持她坚强地活下去的精神力量。从第二拍到第十一拍主要写她的思乡之情。她终于熬过了漫长的12年，还乡的夙愿得偿，"忽遇汉使兮称近诏，遗千金兮赎妾身"。但在喜上心头的同时，一片新的愁云飘来了，她想到自己回乡之日，也是与两个儿子诀别之时。第十二拍中说的"喜得生还兮逢圣君，嗟别稚子兮会无因。十有二拍兮哀乐均，去住两情兮难具陈"，正是这种矛盾心理的表白。从第十三拍起，蔡文姬就转入描写不忍与儿子分别的感情，出语哽咽，沉哀入骨。第十三拍写别子，第十四拍写思儿成梦，极尽缠绵，感人肺腑。这种别离之情、别离之痛，一直陪伴着她离开草原，回到中原。屈辱的生活结束了，而新的不幸——思念儿子的痛苦，才刚刚开始。"胡与汉兮异域殊风，天与地隔兮子西母东。苦我怨气兮浩於长空，六合虽广兮受之应不容。"全诗在感情如

Selected Well-known Chinese Songs
I. Songs from Ancient Times (Five Pieces)

As a prisoner of war, she began her sorrowful life, dramatically illustrated in Po 2. And again in Po 10, she writes, "Separation from my home has caused a lifetime of bitterness." Her lifelong physical and mental misfortune stems from her captivity. Neither could she become accustomed to the severe climate and environment of the north, nor the lifestyle of the Huns, so different from those of Han. "Their customs are different, their minds are unlike, how can I survive among them? / What we like and want are not the same, to whom can I even speak?" Mental anguish was the most unbearable.

As a Han she was a prisoner of war and being a woman, she was forced to marry a Hun. The double humiliation preyed on her mind. The very lines in Po 1 illustrate this: "They ignore my widow's vows, and my chastity is lost." Tortured physically and mentally, she missed her home and longed to return. Only her hope supported her spiritually to stay alive. Po 2 to Po 11 focus on her nostalgia. Finally, after 12 years long, her dream of returning to Han was realized: "Suddenly we meet an envoy from the Han Dynasty, bearing a direct decree, / He brings a thousand pieces of gold as a ransom for me." Happy as she was, a cloud of new sorrow overshadows her, realizing that the day of her departure would be the time to bid the final farewell to her sons. The lines of Po 12 expresses the emotional anguish: "I rejoice that I have lived for a chance to return, thanks to our sagacious king, / But I grieve at parting from my young sons, with no chance of meeting them again. / My twelfth po speaks of sorrow and joy, / Shall I return or to stay?

狂潮般涌动处结束，表现了蔡文姬悲剧性的人生旅程。

下面是该诗的全文，鉴于全诗太长，本书所附的录音中只选取第一、二拍和第十二拍的曲谱并加以演唱。

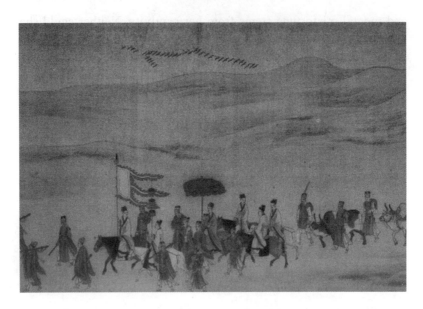

歌词：

【第一拍】

我生之初尚无为，

我生之后汉祚衰。

天不仁兮降乱离，

地不仁兮使我逢此时。

干戈日寻兮道路危，

民卒流亡兮共哀悲。

烟尘蔽野兮胡虏盛，

Selected Well-known Chinese Songs
I. Songs from Ancient Times (Five Pieces)

It's hard to express my mixed feelings." From Po 13 on, she turned to write about her unbearable pain of parting with her sons, choking with sobs, lamenting her life. Po 14 is a touching and lingering remembrance of her sons. Suffering had accompanied her ever since she left the grassland and returned to the Central Plains. Though her days of humiliation were over, there was a new wave of grief of missing her children. "The nomads and Han live in different places with different customs. As the sky is separated from the earth, my children went west and I, their mother, east. My grief, bitterer and greater than the universe, cannot be contained in it, long and wide as it is." The whole narration ends abruptly in a torrent of feelings, pouring out the tragedy of Wenji's life.

The followings are the lyrics of the poem, among our disc only Pos 1, 2 and 12 are sung since the entire work would be too long to be included in the disc.

Lyrics:

Po 1

In the early part of my life, equity still governed the empire,
But later in my life the Han throne fell into decay.
Heaven was not kind, sending down rebellion and chaos,
Earth was not kind, causing me to encounter such a time.
War gear was commonplace, and travel by road was dangerous,
People fled, all plunged in wretchedness.
Smoke and dust darkened the countryside, overrun by

志意乖兮节义亏。
对殊俗兮非我宜,
遭恶辱兮当告谁?
笳一会兮琴一拍,
心愤怨兮无人知。

【第二拍】
戎羯逼我兮为室家,
将我行兮向天涯。
云山万重兮归路遐,
疾风千里兮扬尘沙。
人多暴猛兮如虺蛇,
控弦被甲兮为骄奢。
两拍张弦兮弦欲绝,
志摧心折兮自悲嗟。

Selected Well-known Chinese Songs
I. Songs from Ancient Times (Five Pieces)

invaders;

They ignore my widow's vows, and my chastity is lost.

Their strange customs are so utterly foreign to me,

Whom can I possibly tell of my calamity, shame, and grief?

One measure for *hujia*, the nomad flute, one stanza for the qin,

No one knows my agony and broken heart.

Po 2

The Rong and Jie of the northwest tribes took me by force,

They led me on a journey to the lands at the horizon to wife me.

Ten thousand strata of cloudy peaks, so stretched the returning road,

A thousand miles of piercing winds drove dust and sand.

Extravagantly violent and wild, the people were like reptiles and snakes,

They draw their bows; they wear armor, their bearing arrogant and fierce.

My second po stretches the strings, stretches them to the breaking point,

My will shattered, my heart broken, I lament and sigh.

【第三拍】

越汉国兮入胡城,

亡家失身兮不如无生。

毡裘为裳兮骨肉震惊,

羯膻为味兮枉遏我情。

鼙鼓喧兮从夜达明,

胡风浩浩兮暗塞营。

伤今感昔兮三拍成,

衔悲畜恨兮何时平。

【第四拍】

无日无夜兮不思我乡土,

禀气含生兮莫过我最苦。

天灾国乱兮人无主,

唯我薄命兮没戎虏。

殊俗心异兮身难处,

嗜欲不同兮谁可与语!

Selected Well-known Chinese Songs
I. Songs from Ancient Times (Five Pieces)

Po 3

I traveled across the land of Han and entered foreign domains,

My home was lost, my body violated; better never to have been born.

The felts and furs they are clad in are a shock to my bones and flesh,

In vain do I try to suppress it, but

There is no way to hide my disgust for the taste of their rank-smelling mutton.

War drums pulse through the night until it dawns,

Wind roars with great force, obscures the border and darkens the camps.

With the present heartrending, the past dolorous, my third po is done,

My sorrow builds, my anger mounts; when will there be peace?

Po 4

Not a day or night passes when I do not long for my home,

Of all beings that live and breathe, none could be as bitter as I am.

Heaven unleashes calamity upon an empire in crisis, leaving the people behind without a leader,

But only I have this miserable fate, to be lost among

寻思涉历兮多艰阻，
四拍成兮益凄楚。

【第五拍】
雁南征兮欲寄边声，
雁北归兮为得汉音。
雁飞高兮邈难寻，
空断肠兮思愔愔。
攒眉向月兮抚雅琴，
五拍泠泠兮意弥深。

【第六拍】
冰霜凛凛兮身苦寒，
饥对肉酪兮不能餐。

prisoners of Rong.

 Their customs are different, their minds are unlike, how can I survive among them?

 What we like and want are not the same, to whom can I even speak?

 I brood on what I have suffered and how adverse my fate was.

 My fourth po is finished even more desolately and miserably.

Po 5

 The wild geese fly to the south; I wish they could carry my thoughts from the border,

 The wild geese return to the north; I wish they would bring news from my Han people.

 The wild geese fly high, so remote they are hard to see, or to find;

 My heart is broken, my thoughts dark and hidden.

 Facing the moon with knitted brows I could but strum my elegant Qin,

 My fifth po is thus quiet and clear deepens in meanings.

Po 6

 The ice and frost are shattering, my body is bitterly cold,

 Hungry as I am, I could not take meat and milk for my meal.

夜闻陇水兮声呜咽,
朝见长城兮路杳漫。
追思往日兮行李难,
六拍悲来兮欲罢弹。

【第七拍】

日暮风悲兮边声四起,
不知愁心兮说向谁是!
原野萧条兮烽戍万里,
俗贱老弱兮少壮为美。
逐有水草兮安家茸垒,
牛羊满地兮聚如蜂蚁。
草尽水竭兮羊马皆徙,
七拍流恨兮恶居于此。

Selected Well-known Chinese Songs
I. Songs from Ancient Times (Five Pieces)

At night I listen to the sadly murmuring waters of the Long River,

In the morning I see the Great Wall and roads spreading endlessly.

My thoughts go back to the days past, the journey so very hard,

With the sixth po comes my sorrow, if only I could stop playing.

Po 7

At sunset the wind is harrowing. Sounds at the frontier by nomad flutes rise all around,

I do not know if there is someone to share my grieving heart.

The land is stagnant and desolate, beacons stretching ten thousand miles,

Following their customs, favor the young and strong, the Huns shun the old and weak.

They wander wherever there is water and grass to set up their tents and camps,

Cattle and sheep everywhere swarm like bees or ants.

When the grass is gone and water exhausts, cattle and horses are all on the move,

My seventh po flows with resentment, for I hate living in this place.

【第八拍】

为天有眼兮何不见我独漂流?

为神有灵兮何事处我天南海北头?

我不负天兮天何配我殊匹?

我不负神兮神何殛我越荒州?

制兹八拍兮拟排忧,

何知曲成兮心转愁。

【第九拍】

天无涯兮地无边,

我心愁兮亦复然。

人生倏忽兮如白驹之过隙,

然不得欢乐兮当我之盛年。

怨兮欲问天,

天苍苍兮上无缘。

举头仰望兮空云烟,

九拍怀情兮谁与传?

Selected Well-known Chinese Songs
I. Songs from Ancient Times (Five Pieces)

Po 8

If Heaven had eyes; why would it not see me alone in this wandering?

If gods had power; why would I be placed in the uttermost south of the sky and north of the sea?

I had not offended Heaven; how could it match me with such a strange mate?

I had not offended the gods; how could they cast me into the distant wilderness?

I compose my eighth po to forget my grief,

Why has my sorrow become more intense when the piece is done?

Po 9

Heaven is boundless, so is the earth,

Boundless and unceasing, as is my depression.

Human life passes swiftly, flashing like a white horse passing by a crack,

Here I am in the prime of life with never a day happy!

Filled with complaint, I want to question Heaven,

But it is so vast, which I have no way to reach.

Raising my head to look up, there is nothing but clouds and smoke,

My ninth po conveys my feelings, but to whom can I tell them?

中国名歌选萃
一、古代歌曲（5首）

【第十拍】

城头烽火不曾灭，

疆场征战何时歇？

杀气朝朝冲塞门，

胡风夜夜吹边月。

故乡隔兮音尘绝，

哭无声兮气将咽。

一生辛苦兮缘别离，

十拍悲深兮泪成血。

【第十一拍】

我非贪生而恶死，

不能捐身兮心有以。

生仍冀得兮归桑梓，

死当埋骨兮长已矣。

日居月诸兮在戎垒，

胡人宠我兮有二子。

鞠之育之兮不羞耻，

愍之念之兮生长边鄙。

十有一拍兮因兹起，

哀响缠绵兮彻心髓。

Selected Well-known Chinese Songs
I. Songs from Ancient Times (Five Pieces)

Po 10

The beacons on the fortress are never allowed to die out,

When will the war in the battlefield ever cease?

The urge to kill, day in, day out, assaults the border gates,

The wind of the Hu place, night in, night out, cries to the frontier moon.

I am severed from my home town, cut off from any news,

I cry without a sound, my breath about to choke.

Separation from my home has caused a lifetime of bitterness,

My tenth po deepens my anguish with my tears turning into blood.

Po 11

I am not the one that clings to life for fear of death,

There is a reason that I could not do away with myself.

Alive, I could still cherish the hope of returning to my homeland of mulberries and catalpas,

Dead, everything would be over, my bones buried.

Day after day, month after month I dwell among the nomads,

My nomad husband is fond of me, since I bore two sons for him.

Nurturing them, bringing them up, I am not ashamed of myself,

一、古代歌曲（5首）

【第十二拍】

东风应律兮暖气多，

知是汉家天子兮布阳和。

羌胡踏舞兮共讴歌，

两国交欢兮罢兵戈。

忽遇汉使兮称近诏，

遗千金兮赎妾身。

喜得生还兮逢圣君，

嗟别稚子兮会无因。

十有二拍兮哀乐均，

去住两情兮难具陈。

【第十三拍】

不谓残生兮却得旋归，

抚抱胡儿兮泣下沾衣。

Selected Well-known Chinese Songs

I. Songs from Ancient Times (Five Pieces)

I caress them, pity them for being bred in this wretched frontier.

My eleventh po has risen from this,

The sad tunes entwine, piercing my heart and marrow.

Po 12

The east wind responds to natural recurrences with plenty of warm air,

The Han Son of Heaven is spreading sunshine and peace.

Now the Qiang and the Hu dance the measures and sing in harmony,

The two nations make a truce and put an end to war.

Suddenly we meet an envoy from the Han Dynasty, bearing a direct decree,

He brings a thousand pieces of gold as a ransom for me.

I rejoice that I have lived for a chance to return, thanks to our sagacious king,

But I grieve at parting from my young sons, with no chance of meeting them again.

My twelfth po speaks of sorrow and joy,

Shall I return or stay? It's hard to express my mixed feelings.

Po 13

Though I have never dreamed of returning home alive, I am able to go back now,

汉使迎我兮四牡骓骓，

胡儿号兮谁得知？

与我生死兮逢此时，

愁为子兮日无光辉，

焉得羽翼兮将汝归。

一步一远兮足难移，

魂消影绝兮恩爱遗。

十有三拍兮弦急调悲，

肝肠搅刺兮人莫我知。

【第十四拍】

身归国兮儿莫之随，

心悬悬兮长如饥。

四时万物兮有盛衰，

唯有愁苦兮不暂移。

山高地阔兮见汝无期，

更深夜阑兮梦汝来斯。

梦中执手兮一喜一悲，

Selected Well-known Chinese Songs
I. Songs from Ancient Times (Five Pieces)

Embracing my nomad sons, tears soak our clothes.

To escort me the envoy from the Han Dynasty have a team of horses,

Who cares that my nomad children cry and wail?

Who knows there comes a time that would separate the mother and the sons like life and death?

The sun lost its brightness, because of my mourning for my sons.

If only I had wings to take you back with me!

One step after another I walk farther and farther away, though my feet could hardly move.

Our souls devastate, our shadows part, what is left is only my love,

In my thirteenth po the beats are hurried, the tunes, sad,

My bowels were as though cut to pieces; no one know what I have suffered.

Po 14

My body returns to my country, my sons are too young to understand,

My heart remains lingering as if I were forever hungry.

Seasons and creatures flourish and wane in time,

While grief and bitterness are my constant companions.

High mountains and boundless land deprive me of hope to meet you again,

觉后痛吾心兮无休歇时。

十有四拍兮涕泪交垂,

河水东流兮心是思。

【第十五拍】

十五拍兮节调促,

气填胸兮谁识曲?

处穹庐兮偶殊俗。

愿得归来兮天从欲,

再还汉国兮欢心足。

心有怀兮愁转深,

日月无私兮曾不照临。

子母分离兮意难任,

同天隔越兮如商参,

生死不相知兮何处寻!

Selected Well-known Chinese Songs
I. Songs from Ancient Times (Five Pieces)

Deep in the night I dream of you coming here.

In the dream we hold each other's hands, joyfully as well as sorrowfully,

Awaken to the pain in my heart, the dream left me without a moment's rest.

I write my fourteenth po with tears streaming down my face,

As the river flows eastward, my heart flows toward my sons.

Po 15

In my fifteenth po the tempo of the melody quickens,

Who understands my song filled with my indignation and hatred?

I lived in a yurt with the nomads, their customs different and strange,

Heaven granted me my wish to return to my homeland.

Being back to the Han country gladdened my heart, memories of which only fed my ever-deepening sorrow.

The sun and moon are impartial, yet they fail to shine on me,

Hard to bear the thought that children and the mother are separated ever.

Though under the same sky, like distant constellations, we are not to meet each other again,

No news of each other, nowhere to find each other, whether we are living or dying.

一、古代歌曲（5首）

【第十六拍】

十六拍兮思茫茫，

我与儿兮各一方。

日东月西兮徒相望，

不得相随兮空断肠。

对萱草兮忧不忘，

弹鸣琴兮情何伤！

今别子兮归故乡，

旧怨平兮新怨长！

泣血仰头兮诉苍苍，

胡为生兮独罹此殃！

【第十七拍】

十七拍兮心鼻酸，

关山阻修兮行路难。

去时怀土兮心无绪，

来时别儿兮思漫漫。

塞上黄蒿兮枝枯叶干，

沙场白骨兮刀痕箭瘢。

风霜凛凛兮春夏寒，

人马饥豗兮筋力单。

岂知重得兮入长安，

叹息欲绝兮泪阑干。

Selected Well-known Chinese Songs
I. Songs from Ancient Times (Five Pieces)

Po 16

My sixteenth po I write while my thoughts wandering,

With a broken heart, I am here while my sons are there.

Just as the sun is in the east while the moon is in the west, only looking at each other from a distance, unable to meet.

Facing a tawny daylily, they can only think of me,

Playing the *qin*, I am afflicted with misery.

Returning home today, I bid my farewell to my sons,

New worries replace the old woe.

Bleeding with tears, I raise my head to ask the firmament,

Whether I was born to suffer like this.

Po 17

In my seventeenth po, my heart wrenches, my nose is sore,

It is hard to travel along the dangerous road, long and winding through the mountain passes.

Longing for my home, I leave as a fallen dried leaf,

In the battlefields are white bones scarred with arrows and swords.

It is cold even in spring and summer; wind and frost freeze the marrow,

Meager and lonely are hungry people and hungry horses.

What a surprise to know that I would go back to Chang'an again!

Overjoyed with a deep sigh; I let my tears fall.

【第十八拍】

胡笳本自出胡中，

缘琴翻出音律同。

十八拍兮曲虽终，

响有余兮思无穷。

是知丝竹微妙兮均造化之功，

哀乐各随人心兮有变则通。

胡与汉兮异域殊风，

天与地隔兮子西母东。

苦我怨气兮浩於长空，

六合虽广兮受之应不容！

Selected Well-known Chinese Songs
I. Songs from Ancient Times (Five Pieces)

Po 18

The *hujia*, the nomad flute played by the nomads,

Follows the same music patterns as I perform its melody on my *qin*.

Although I finish writing and playing my eighteen pos,

Its melody lingers, and my thoughts go far away.

To show how subtly strings and pipes are played to reflect the work of Creation.

In sorrow and joy music traces people's hearts and changes its tunes to catch them,

The nomads and Han live in different places with different customs.

As the sky is separated from the earth, my children go west and I, their mother, east,

My grief, bitterer and greater than the universe,

Cannot be contained in it, long and wide as it is.

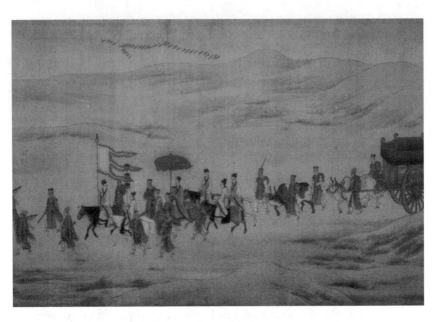

文姬归汉

Wenji returning Han

阳关三叠 ③ Three Variations of a Farewell Song at Yang Pass

扫码欣赏
Scan the code to appreciate

琴歌　唐　王维词
A qin song, lyrics by Wang Wei in the Tang Dynasty （618–907）

中国名歌选萃
一、古代歌曲（5首）

琴歌是用古琴伴奏的歌唱形式，一般由同一个人演奏或演唱，为古代文人所喜爱。从《尚书·益稷》"搏拊琴瑟以咏"的记载来看，琴歌有悠久的历史，早在先秦时期已经出现。魏晋南北朝的相和歌、隋唐的清乐，都以古琴为重要的伴奏乐器，宋、元以来，更出现了一些提倡琴歌的琴人和琴派。琴歌大致有两种不同的类型：一是从民歌中汲取营养创造的；二是文人自己创造的。《阳关三叠》是第二类琴歌的代表作，它的歌词来自唐代诗人王维的七言绝句《送元二使安西》，因诗中有"阳关"与"渭城"这两个地名，所以得名《阳关曲》或《渭城曲》。

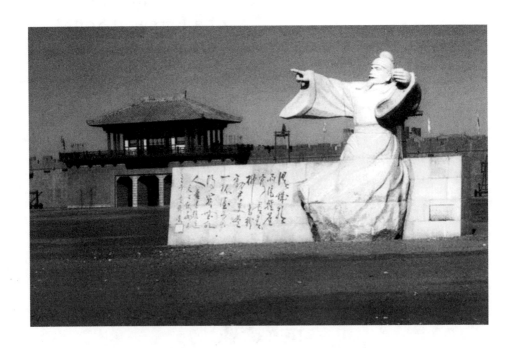

王维（701—761），字摩诘，在诗歌、绘画两方面都取得了卓越的成就。宋代大文豪苏东坡称："味摩诘之诗，诗中有画；观摩诘之画，画中有诗。"他的诗、画在描写自然景物方面有其独到的造诣。无论是名山大川的壮丽宏伟，边疆关塞的辽阔荒芜，

Selected Well-known Chinese Songs
I. Songs from Ancient Times (Five Pieces)

The *qin* song, i.e., "to sing a song accompanied by a *qin*", was a very popular way of singing among literati in ancient China. Usually, the performer sang while accompanying himself on the *qin*. The history of this genre of performance can be traced back to the pre-Qin period (before 221 BC). According to the article, "Yiji", in the *Book of Documents*, singing accompanied by the *qin* and the *se*, another plucking instrument, became common at that time. Later the *qin* was continuously used as an important accompanying instrument in the performance of *xianghe* song in the Wei, Jin, Northern and Southern Dynasties, and that of *qin* music in the Sui and Tang Dynasties. Those who advocated this style of performance were called *qin* people and *qin* school which appeared in the Song and Yuan Dynasties. Generally, there are two types of *qin* songs, one of which was developed from folk songs, and the other was created by the literati themselves. "Three Variations of a Farewell Song at Yang Pass" is of the latter type. Originally the verse was a seven-character quatrain called "A Farewell to Yuan Er on His Mission to Anxi" by the Tang Dynasty poet and painter, Wang Wei. Since two places, Yang Pass and Wei Town are mentioned in the poem, "Three Variations of a Farewell Song at Yang Pass" is also called "The Song of Yang Pass" or "The Song of Wei Town".

Wang Wei (701–761), styled Mojie, was a remarkable painter and poet. "Reading Mojie's poems evokes pictures in my mind, and enjoying his pictures, I hear poetry," commented Su Dongpo, a sage from the Song Dynasty. Indeed, Wang Wei's paintings and poems are

一、古代歌曲（5首）

或者是小桥流水的恬静安逸，在王维的笔下都能准确、精练地被塑造出完美无比的鲜活形象，着墨无多、意境高远，诗情与画意完全融合为一个整体。王维一些赠送亲友和描写日常生活的抒情小诗，感情真挚，语言明朗自然，不加雕饰，具有淳朴深厚之美，可与李白、王昌龄的绝句比美，代表了唐代诗歌创作的最高成就，千百年来为人们所喜爱和传诵。

《送元二使安西》这首诗饱含深沉的惜别之情，表达了作者对即将远行的友人无限留恋的诚挚情感。此诗在唐代便已广为传唱，被收入《伊州大曲》作为第三段，说明其音乐和唐代大曲有一定的联系。

这首琴歌在流传的过程中，加入了新的歌词，真实地反映了别愁离恨，加之旋律感人，千百年来传唱不绝。苏东坡很欣赏它，并在送别友人时亲自吟唱。这首琴歌的曲谱最早见于1491年以前出版的《浙音释字琴谱》，另外还有1511年出版的《太古遗音》等十几种不同的谱本。

Selected Well-known Chinese Songs
I. Songs from Ancient Times (Five Pieces)

unique in fusing poetic romance with natural beauty. Whether it was the magnificence of well-known mountains and rivers, the desolation of border areas, or the quiescence of a village near a small bridge over a brook, all were expressed in refined and vivid images and profound aesthetic connotations with little ornamentation. His poems presented to friends, or the verses describing daily life were written without affectation, expressing raw and unsophisticated feelings in clear and simple language, natural and bright expression, matching the works of Li Bai and Wang Changling. Representing the highest achievement in poetry of the Tang Dynasty, his works are loved and read by people even today.

"Three Variations of a Farewell Song at Yang Pass" is a song of deep feelings at parting with a friend who was to go on a long journey. It was well known even at the time, and was recorded as the lyrics of the third movement in *Grand Music of Yizhou*, which implies that its notation has some connection to Grand Music of the Tang Dynasty. Grand Music is called *daqu* in Chinese and it includes dance, instrumental music and singing and often performed in the royal palace of the Tang Dynasty.

In time, new lines were added to the original verse, lines which express sorrowful feelings of people at parting. The song has been popular for several hundreds of years for its touching feelings and melody. Su Dongpo of the Song Dynasty liked it very much. He himself sang it for friends when saying farewell. Its notation kept in *Notations of Lyrics with Explanation in the Zhe Dialect* published

全曲共分三大段，用一个基本曲调将原诗反复咏唱三遍，并

三次重唱原诗，所以人们就把它称为《阳关三叠》。"叠"是指叠奏，即基于同一曲调的自由反复、变奏或即兴发挥的音乐结构方式。

三叠中的每一叠都分主歌和副歌两个部分。琴歌开始加了一句"清和节当春"作为引句，其余均用王维原诗。后段为新增歌词，每叠不同，带有副歌的性质。第一叠的副歌部分一开始就出现了八度大跳，音乐起伏跌宕，歌词也变成了参差不齐的长短句，表达了主人送别友人时的无限感伤，渲染了"宜自珍"的惜别之情。第二叠音乐的变化主要是在主歌部分，第三叠的变化则主要是在副歌部分，分别描写了"泪沾巾"的忧伤情感和"尺素申"的期待情绪。旋律以五声商调式为基础，音调纯朴而富于激情，特别是最后一段"尺素申，尺素申"等处的八度跳进及"尺素频申，如相亲，如相亲"等处的连续反复陈述，情真意切，激动而沉郁，充分表达出作者对即将远行的友人的无限关怀与留恋的诚挚情感。歌曲结尾处渐慢、渐弱，抒发了一种感叹的情绪。

Selected Well-known Chinese Songs
I. Songs from Ancient Times (Five Pieces)

before the year 1491 is believed to be the earliest. More than ten different versions of the notation were recorded since then, such as the one in *Notations Passed-down from Ancient Times* published in 1511.

The song is divided into three stanzas based on the original poem, with its main tune and lyrics repeated three times. That's why it is called "Three Variations of a Farewell Song at Yang Pass". Variation here refers to a kind of music structure that repeats or improvises on the original tune. In each variation, there is a verse and a refrain. The first variation begins with "It's *Qinhe* Festival (which is on the eighth day of the fourth month according to Chinese lunar calendar) in the time of spring...", followed by the lines of Wang Wei's poem. Then new lines with a little difference are added to each variation to serve as a refrain. At the end of the first variation melody raises an octave to express the feelings of reluctantly parting. The original poem with regular beats and rhythms is also changed into lyrics of long or short sentences to express the singer's infinite sadness, rendering his reluctance to part with his friend. The change in the second variation occurs in its verse, while that of the third is in the refrain. Sorrow and expectation for letters are described respectively in the two stanzas. Based on the pentatonic scale, the main melody is simple yet passionate. The melody is high in range at the words of the last stanza "write to me, write to me", and the repetition of the sentence "Your frequent letters would make me feel as if you had never left" fully expresses the singer's feelings for his friend who is to go afar away. The ending of the song is slow, with a decrescendo to express the

中国名歌选萃
一、古代歌曲（5首）

歌词：

（1）清和节当春，

渭城朝雨浥轻尘，

客舍青青柳色新。

劝君更尽一杯酒，

西出阳关无故人！

霜夜与霜晨。

遄行，遄行，长途越渡关津，

惆怅役此身。

历苦辛，历苦辛，历历苦辛，宜自珍，宜自珍。

（2）渭城朝雨浥轻尘，

客舍青青柳色新。

劝君更尽一杯酒，

西出阳关无故人！

依依顾恋不忍离，

泪滴沾巾，

无复相辅仁。

感怀，感怀，

思君十二时辰。

参商各一垠，

Selected Well-known Chinese Songs
I. Songs from Ancient Times (Five Pieces)

composer's plaint and sigh.

Lyrics:

(1) Its *Qinhe* Festival in the springtime

When the dust in Wei Town is dulled with rain in the morning which washes the tavern tiles clean and the willows yellowish green,

Have another cup of wine,

Because going west through Yang Pass, there will be no more acquaintances.

Trekking and trudging on frozen roads from morning till night,

You have a long way to go, a great many passes and rivers to cross,

Suffering hardships on the sad and tiring journey, you must

Take care, take care of yourself.

(2) When the dust in Wei Town is dulled with rain in the morning which washes the tavern tiles clean and the willows yellowish green,

Have another cup of wine,

Because going west through Yang Pass, there will be no more acquaintances.

Tears are rolling down my face, wetting my kerchief,

Such a good friend, I will never see again.

I'll miss you, miss you.

I will be missing you twenty-four hours a day.

谁相因,谁相因,

谁可相因,

日驰神,日驰神。

(3) 渭城朝雨浥轻尘,

客舍青青柳色新。

劝君更尽一杯酒,

西出阳关无故人!

芳草遍如茵。

旨酒,旨酒,

未饮心已先醇。

载驰骃,载驰骃,

何日言旋轩辚,

能酌几多巡!

千巡有尽,

寸衷难泯,

无穷的伤感。

(4) 楚天湘水隔远滨,

期早托鸿鳞。

尺素申,尺素申,尺素频申,

Selected Well-known Chinese Songs
I. Songs from Ancient Times (Five Pieces)

Yet, like Cen Star and Shang Star in the heavens, the two of us are parted forever.

Being apart, whom will I be connected with? Whom can I be connected with?

I am restless every day as my thoughts are always with you,

Always with you.

(3) When the dust in Wei Town is dulled with rain in the morning which washes the tavern tiles clean and the willows yellowish green,

Have another cup of wine,

Because going west through Yang Pass, there will be no more acquaintances.

The fragrant grass everywhere is as dense and green as a blanket.

The mellow wine makes us drunk before we drink.

The loaded horses are ready to go, but

When can you turn your official carriage homeward?

How many more cups of wine can you have now?

Even to a thousand there must be an end,

Yet, my sorrow will never die, and

The sadness in my heart is endless.

Coda:

Since we will soon be far away from each other,

I hope you will write me soon.

如相亲,如相亲。

噫!

从今一别,

两地相思入梦频,

鸿雁来宾。

Selected Well-known Chinese Songs
I. Songs from Ancient Times (Five Pieces)

 Your frequent letters would make me feel as if you had never left.

 Farewell! From now on, living apart, we can only meet in a dream.

 Remember, I am always waiting for the swan goose bringing your letters to me.

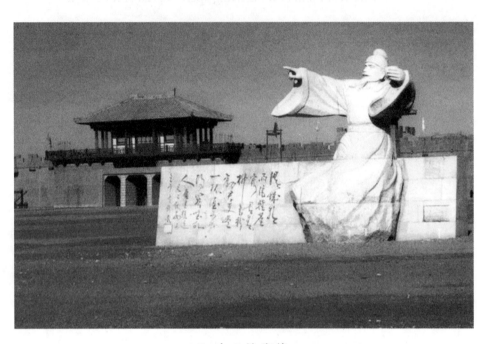

阳关王维塑像
Statue of Wang Wei at Yang Pass

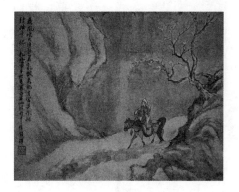

杏花天影 ④ Apricot Blossoms Against the Sky

扫码欣赏
Scan the code to appreciate

艺术歌曲　宋 姜夔词、曲
An art song, lyrics and music by Jiang Kui of the
Song Dynasty (960–1279)

中国名歌选萃
一、古代歌曲（5首）

姜夔（1154—1221），字尧章，号白石道人，江西鄱阳人。南宋文学家、书法家、音乐家。一生未曾仕宦，靠卖字及朋友周济为生，往来鄂、赣、皖、苏、浙间，与诗人杨万里、范成大、辛弃疾等交游。他多才多艺，精通音律，能自度曲，其词格律严密。其作品以空灵含蓄著称，有《白石道人诗集》《白石诗说》，并有《白石道人歌曲》传世。

姜夔所处的时代，南宋和金朝南北对峙，战争带来的灾难和人民的痛苦使他非常痛心，这种凄凉的心情表现在他的诗歌和音乐作品中。姜夔今存词80多首，多为记游、咏物和抒写个人身世、离别相思之作，也流露出对于时事的感慨。其词情意真挚，格律严密，语言华美，风格清幽冷隽，笔调瘦硬清刚，矫媚婉约。代表作有《暗香》《疏影》，借咏叹梅花，感怀身世，抒发郁郁不平之情。

Selected Well-known Chinese Songs
I. Songs from Ancient Times (Five Pieces)

Known by his literary name as Baishi Daoren (Yaozhang name given at his birth), Jiang Kui (1154–1221), was born in Poyang, Jiangxi Province. He was a literati, calligrapher, and musician who lived during the Southern Song Dynasty (1127–1279). Unlike many literati holding government positions in ancient China, Jiang Kui had never held an office. He earned a meager living by selling his calligraphic works, sometimes relying on his friends' help. He traveled to many places including Hubei, Jiangxi, Anhui, Jiangsu, and Zhejiang provinces, making friends with poets such as Yang Wanli, Fan Chengda and Xin Qiji. A master of musical pitch, a composer of songs and melodies, he was also a versatile wit. Meters and rhythms of his poems were rigorous and neat, but at the same time ethereal and reserved. His works such as *Poetry Anthology by Baishi Daoren*, *Poems Recited by Baishi*, and *Collections of Songs by Baishi* have survived.

Jiang Kui lived during a time when the Southern Song was at a stalemate with Jin in the north. Distressed by the disasters of war and people's sufferings, Jiang Kui expressed his feelings in his poetry and music, among which over 80 *ci* poems have been preserved. The poems are about travel, singing things, his life, and love. Some of them give expression to his ideas on current events. Sincere and true in feelings, beautiful and resplendent in language, rigorous and neat in poetic rules and forms, limpid and serene in style, upright and elegant in tones, his works are graceful and restrained. His masterpieces are "Delicate Fragrance" and "Thin Shadows". In those

姜夔早年曾客居安徽省合肥市,与一对善弹琵琶的姊妹相遇,从此与其中一位结下不解之缘,却因生计不能自足而不得不游食四方,遂无法厮守终老。姜夔的词中,写与此情有关的有22首之多,占其全部词作的四分之一,足见其萦心不忘。这也使得他的词具有极为感人的品质。

1197年,姜夔以多年来对音乐的研究写出了《大乐议》和《琴瑟考古图》各一卷,呈献给南宋朝廷,用以议正乐典。他注重琴学的研究,在《七弦琴图说》一文中阐述了南宋时代的古琴宫调,提出了分琴为三准(自一徽至四徽为上准,四徽至七徽为中准,七徽至龙龈为下准),三准各具十二律的理论,并论述了转弦合调以及在琴上弹奏"应声"(即为各调 do)的手法等。这些撰著对研究宋代音乐和古琴的演奏方法有很高的价值。

《白石道人歌曲》收词80首,其中17首附有曲谱。17首中的《扬州慢》《杏花天影》《姜凉犯》《暗香》《疏影》《徵招》《角招》等14首是姜夔自己创作的词调;3首是为他人的词谱曲,其中一首是范成大的《玉梅令》。这17首歌曲都用宋代的俗字谱写在歌词旁边。这些乐谱是他一生音乐创作的精髓,是研究宋

Selected Well-known Chinese Songs
I. Songs from Ancient Times (Five Pieces)

two poems he describes blooming plum flowers to convey his sorrow and disappointments.

In his early years, Jiang Kui lived in Hefei, Anhui Province for a while and met two girls who were sisters. Both girls were good at playing the *pipa* (Chinese lute). He fell in love with one of them, but he had to leave her due to his poor financial conditions. Among all his *ci* poems, 22 especially touching poems are about unfulfilled love, which reflects the depth of his affections.

In 1197, Jiang Kui submitted two works to the royal court based on his research results of many years. They were *Comments on Grand Music* and *An Archeological Study on the Qin and the Se with Pictures*. His aim was to set a standard for official music. He also gave great attention to the study of the *qin*. In his article, "A Study on the Qin with Pictures", he explains the modes of the *qin* according to the Southern Song standard: From the first *hui* to the forth is the upper mode; from the forth to the seventh is the intermediary one, and from the seventh to the Dragon's Gum is the lower one. Each contains twelve tones. He also expounds on the methods of tuning the strings and how to play the *yingsheng* (do#) on the *qin*. His books are invaluable for the study of the music in the Song Dynasty as well as techniques for playing the *qin*.

There are 80 *ci* poems in the *Collections of Songs by Baishi*, and among them, 17 also have notations. Among those 17 songs, 14 lyrics were written by Jiang Kui himself. These are "Yangzhouman", "Apricot Blossoms Against the Sky" and "Jiangliangfan", "Delicate Fragrance", "Thin Shadows", "Zhizhao" and "Juezhao". Lyrics of other 3

代音乐的重要资料。

《杏花天影》写于1187年春，作者当时客居金陵（今南京），面对春天的美景，想到自己客居他乡，四处漂流，不知何处是归宿，不由愁绪倍添，因有所作。这首词的主要内容是思念远在合肥的恋人。上阕，梦见伊人，惊醒成空，便假托对方的幽魂，来而又去，故词中出现的人物以对方为主，由"桃叶"而触动思念恋人的愁思，"待去"写出欲去未去的踌躇。下阕向恋人表白身不由己的隐痛，全词文笔细腻，深情动人。

《杏花天影》的歌词精工细琢，颇有婉约之风。其词调为姜夔自创。上下阕都用同一音乐素材，只是下阕采用了传统音乐中"换头"的手法，第一乐句和前阕不同，曲调出现大幅度跳进，使歌曲在忧郁中透出激情，描绘出姜夔千种愁思绵延不断的情怀。

歌词：

绿丝低拂鸳鸯浦。

Selected Well-known Chinese Songs
I. Songs from Ancient Times (Five Pieces)

songs were written by other poets but the music were composed by Jiang Kui. Among these 3, the lyrics of "To the Tune of Jade Plum Blossoms" was written by Fan Chengda. The music was written in colloquial notations of the Song Dynasty. The notations of these 17 songs are the quintessence of Jiang Kui's life-long efforts.

"Apricot Blossoms Against the Sky" was written in the spring of 1187 when Jiang Kui lived in Nanjing. The beautiful spring only added sadness to his gloomy mood. Vagrant, roving from place to place with no home of his own, Jiang Kui wrote the poem, longing for the lady he loved who lived far away in Hefei. In the first stanza, he describes meeting the lady in a dream only to find it an illusion when waking with a start. He imagines the lady coming to him and leaving him again. His hesitation and reluctance to part with her is shown in the words, "We are about to part…" In the last stanza, he expresses his pain for not being master of his fate. Deep in feelings and exquisite in expressions, the entire poem is moving.

Meticulously and finely written, the lyrics of "Apricot Blossoms Against the Sky" is of a graceful and restrained style. Jiang Kui wrote the lyrics as well as the music. The same musical material is used in both the first and the second stanzas. But the beginning of the second stanza uses a traditional method of making a big leap in pitch. He uses this method to highlight his passion and endless misery in the gloomy tone.

Lyrics:

Willow strands droop low to stir the pond where mandarin ducks swim,

想桃叶、当时唤渡。
又将愁眼与春风,待去。
倚兰桡,更少驻。

金陵路、莺吟燕舞,
算潮水、知人最苦。
满汀芳草不成归,
日暮,更移舟,向甚处?

Selected Well-known Chinese Songs
I. Songs from Ancient Times (Five Pieces)

　　It reminds me of a lady called Peach Leaf who once asked me to cross the river here.
　　I shall be raising my melancholy eyes to follow the spring breeze, as we are about to part,
　　I lean on the paddle to linger a little longer.

　　Sailing past Jinling, I pass by the dancing figures of soft spoken ladies.
　　I guess tides know best that the most toilsome of our obligation is to endure life.
　　The verdure spreads over the sandbar, leaving no way home,
　　In the sunset, I steer the boat along, but to where?

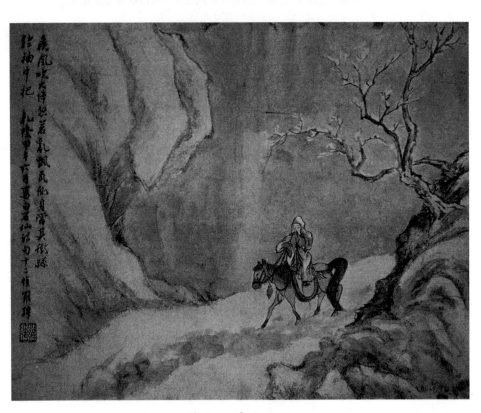

姜白石诗意国画
Jiang Baishi's poetic traditional Chinese painting

满 江 红 ⑤ Manjianghong(Azolla)

扫码欣赏
Scan the code to appreciate

古曲　宋　岳飞词
An ancient melody, lyrics by Yue Fei
of the Song Dynasty (960–1279)

这首歌的词是气壮山河、传诵千古的名篇，其作者是宋代名将岳飞。

岳飞（1103—1142），字鹏举，河南省安阳市汤阴县人，为抗金名将，也是当时最杰出的军事统帅。岳飞年幼时，亲眼所见了女真入侵、山河破碎、国破家亡的悲惨景象。他少年从军，以"精忠报国"为己任，为收复失地，曾统领军队，转战各地，艰苦斗争。此词作于公元1136年，这年岳飞率军从襄阳出发北上，陆续收复了洛阳附近的一些州县，前锋逼近北宋故都汴京，大有一举收复中原、直捣金国首都之势。但此时的南宋皇帝高宗一心与金国议和，命岳飞立即班师，岳飞不得已率军回到鄂州。他痛感坐失良机，收复失地、雪耻报仇的志向难以实现，在百感交集中写下了这首词。

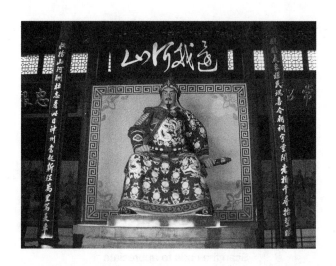

岳飞回到当时的南宋首都杭州，立即陷入奸臣秦桧、张俊等人布置的圈套。1142年1月27日，秦桧以"莫须有"的罪名将岳飞毒死。1162年，宋孝宗即位，准备北伐，下诏为岳飞平反，

Selected Well-known Chinese Songs
I. Songs from Ancient Times (Five Pieces)

Sublime and heroic, the lyrics of this song are so famous that it is widely read for hundreds of years. Its writer is Yue Fei, the famous general of the Song Dynasty.

Born in Tangyin, Henan Province, Yue Fei (1103–1142), (birth name Pengju), was a famous general of the Song Dynasty, and the most outstanding marshal of the time fighting against the Jin invasions. In his childhood, he witnessed the disintegration of his country and the death of thousands of people. To regain the lost territory, he joined the army when quite young, serving with supreme loyalty. As a general, he led his troops into arduous battles. The poem was written in 1136, when Yue Fei led his army north from Xiangyang, Hubei Province, retaking several lost cities and towns around Luoyang, Henan Province. His vanguard troops almost regained Bianjing, the former capital of the Northern Song Dynasty. It seemed likely that he would succeed in one stroke in retaking all the lost areas, and even move onto the capital of the Jin. However, Gaozong, the emperor of the Southern Song decided to make peace with the Jin, so he ordered Yue Fei to withdraw troops immediately from the front. Yue Fei and his army were forced to return to Ezhou, Hubei Province. Feeling keenly that the golden opportunity of retaking the lost territories and wiping out the humiliation would never be achieved, he poured out his bitterness in this poem.

Shortly after Yue Fei returned to Hangzhou, the capital of the Southern Song Dynasty, he was trapped into a conspiracy by two treacherous court officials, Qin Hui and Zhang Jun. On Jan. 27th,

并将他的遗体改葬在杭州西湖畔。

岳飞作为中国历史上的杰出人物之一,其精忠报国的品质深受我国各族人民的敬佩。此词上阕通过凭栏眺望,抒发为国杀敌立功的豪情;下阕表达雪耻复仇、重整乾坤的壮志。全词情调激昂,慷慨壮烈,至今仍激励着中华儿女的爱国精神。

从我国诗歌史来看,宋代是词兴盛的时代,那时的词都是用固定的曲牌来演唱的,《满江红》是宋词的一支曲牌,但这支曲牌在宋代的具体唱法现已不可考。清代编辑的歌曲集《九宫大成》一书中,记录了几种不同的《满江红》曲调,但都比较柔和纤细,用它们来唱岳飞这首词,显然很不合适。1920年,在"北京大学音乐研究会"所编的《音乐杂志》第一号上,发表了另一种《满江红》的曲调,所配的是元代回族诗人萨都剌的《满江红·金陵怀古》。关于这首曲调的来源,现尚未查明,一般称为"古曲"。这一曲

Selected Well-known Chinese Songs
I. Songs from Ancient Times (Five Pieces)

1142, Qin Hui condemned Yue Fei to death and it was executed based on false accusations. It was not until 1162 when Emperor Xiaozong, who succeeded to the throne and was determined to retake the lost areas in the north, sent out an imperial decree to rehabilitate Yue Fei. His body was exhumed and reburied on the bank of West Lake in Hangzhou.

As an eminent national hero, Yue Fei is respected and esteemed by all Chinese people for his patriotism. The upper stanza shows him leaning against a balcony, gazing into the distance, expressing his determination to fight the enemy, while the lower stanza expresses his ambition to retake the lost territories and reunite the torn land. The poem has always been a patriotic inspiration for the Chinese people.

During the Song Dynasty, there developed a poetic form called *ci* poem which was sung in fixed musical melodies called *qupai*. "Manjianghong" is an example of *qupai*. However, the original music has been lost; therefore, we don't know how it was sung. In *Jiugong Dacheng*, a collection of songs compiled in the Qing Dynasty (1636–1912), there are several different musical versions of "Manjianghong". Yet all these versions seem too mild for Yue Fei's *ci* poem. However, in 1920 another score was found and published in Volume 1 of the magazine *Music*, edited by the Music Institute of Peking University. The music was for another *ci* poem entitled "Manjianghong—Thinking of the Past in Jinling" written by Sa'dal-Allāh, a poet of Hui nationality during the Yuan Dynasty (1271–1368). The origin of this music has not yet been determined. Thus it is generally called an "ancient tune" of a tragically majestic feeling. In 1925, Yang Yinliu, a renowned expert on Chinese music history sang Yue Fei's

调的情调甚为悲壮雄伟。1925年,我国著名音乐史专家杨荫浏先生将岳飞的《满江红》配上这首"古曲",词曲结合贴切,取得了良好的艺术效果,后来人们便用这一旋律演唱岳飞的《满江红》。

1931年9月18日,日本帝国主义发动"九一八"事变,占领了我国东北地区,从那时起,在抵御侵略的斗争中和战争的艰苦岁月里,这首歌与时代精神相结合,成为一首抒发爱国情怀的歌曲,唱遍了长城内外、大江南北,鼓舞了全中国人民与敌人血战到底,直至胜利。

这首《满江红》不仅是一首优秀的独唱歌曲,还被改编为器乐曲、合唱或用于电影音乐,受到群众的热烈欢迎。

歌词:

怒发冲冠,凭阑处、潇潇雨歇。

抬望眼、仰天长啸,壮怀激烈。

三十功名尘与土,八千里路云和月。

莫等闲、白了少年头,空悲切。

靖康耻,犹未雪。臣子恨,何时灭?

驾长车,踏破贺兰山缺。

壮志饥餐胡虏肉,笑谈渴饮匈奴血。

待从头、收拾旧山河,朝天阙。

Selected Well-known Chinese Songs

I. Songs from Ancient Times (Five Pieces)

ci poem "Manjianghong" with this ancient tune, which well matched the lyrics, achieving a good artistic effect. From then on, Yue Fei's "Manjianghong" has been sung to this tune.

Since September 18, 1931 when northeast China struggled against the Japanese invasion, this song was sung all over the country to express patriotism.

Yue Fei's *ci* poem, "Manjinghong", is not only an excellent solo piece, but also well suited for instrumental music, chorus, and film music.

Lyrics:

Wrath sets on end of my hair; I lean on railings where I see the drizzling rain has ceased.

Raising my eyes

Toward the sky, I have long sighs,

My wrath not yet appeased.

To dust is gone the fame achieved in thirty years; Like cloud veiled moon the thousand-mile land disappears. Should youthful eads in vain turn grey? We would regret for aye?

Lost our capitals,

What a burning shame!

How can we generals quench our vengeful flame!

Driving our chariots of war, we'd go

To break through our relentless foe.

Valiantly, we'd cut off each head; Laughing, we'd drink the blood they shed.

When we've conquered our lost land, in triumph would return our army grand.

中国名歌选萃
Selected Well-known Chinese Songs

民歌（10首）

Folk Songs(Ten Pieces)

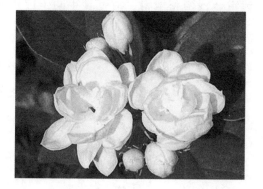

茉莉花 ⑥ Jasmine

扫码欣赏
Scan the code to appreciate

江苏民歌
A folk song of Jiangsu Province

《茉莉花》是一首在全中国都非常流行的、著名的汉族民歌。在玩花主人选辑、钱德苍增辑、清乾隆年间（1736—1795）出版的戏曲剧本集《缀白裘》第六集卷一《花鼓》中就刊登过其唱词："好一朵茉莉花，好一朵茉莉花，满园的花开赛不过了它，

本待要采一朵戴，又恐怕看花的骂。"此词和目前民间唱的几乎完全一样，说明这首民歌在我国至少已经流行了200多年。1838年出版的由贮香主人编的《小慧集》中，收录了用我国古代乐谱工尺谱记录的一首当时流行的民歌《鲜花调》，与现在流传全国的《茉莉花》旋律轮廓大体一致。

《茉莉花》也是最早传到外国的中国民歌之一。1792年至1794年间，任英国驻华大使馆秘书的地理学家约翰·巴罗返国后，于1804年出版了《中国旅行》一书，书中提到，"《茉莉花》似乎是全国最流行的歌曲"，他还说，此前已有希特纳先生的记谱，而且加上了引子、尾声和伴奏，但他认为那样做"就不再是中国朴素的旋律标本了"，所以，巴罗按照中国人演唱和演奏的那样，"还它以不加装饰的本来面貌"。其唱词和《缀白裘》记录的版本基本一样，但乐谱较之《小慧集》所记录的少了许多装饰音，更为朴素。在巴罗的书出版后，欧美出版的多种歌本和音乐史著作中都引用了这首民歌，意大利作曲家普契尼在歌剧《图兰多特》

Selected Well-known Chinese Songs
II. Folk songs (Ten Pieces)

Very well-known all around China, "Jasmine" is a household folk song of the Han nationality. As early as the Qianlong period (1736–1795) of the Qing Dynasty, the lyrics of "Jasmine" were published in "Flowery Drum Opera", Volume 1, Book 6 of *Zhui Baiqiu*, a collection of Chinese drama scripts edited by Wanhua Zhuren and later with expansions by Qian Decang. The lyrics are: Beautiful jasmine! Beautiful jasmine! In the entire garden no other flowers can match it. I'd love to wear it in my hair, but I am afraid to be scolded by the gardener if I pick it.

The lyrics recorded in "Flowery Drum Opera" are almost the same as what people sing today, showing "Jasmine" has been popular for at least 200 years. "Flower Tune", a well-known folk song of the time, recorded in *Xiaohuiji* by Zhuxiang Zhuren in 1838 using gongche notation, has nearly the same melody as that of "Jasmine" sung today.

"Jasmine" is also one of the earliest Chinese folk songs to reach foreign countries. John Bellow (1769–1848), a geographer, working in China from 1792 to 1794 as a secretary at the British Embassy, published *A Travelogue from China* after returning to Britain in 1804, in which he mentioned "Jasmine" as the most popular song in China. He also said that although Mr. Hittner had recorded the notation of "Jasmine" and added an introduction, a coda, and composed accompaniment, he did not think it was the right thing to do since "the song with the added parts lost the simplicity of its paradigmatic Chinese melody". Thus in accordance with what is sung and played

的第一幕中曾采用其旋律编写了一段男声合唱,因为这首歌具有浓郁的中国风格,受到了全世界听众的欢迎。

《茉莉花》几乎在全国各地都有流传,人们不仅演唱它,还把它改编成各式各样的器乐曲,其中有独奏曲,也有合奏曲。各地流行的《茉莉花》歌词基本相同,都以反映青年男女纯真的爱情为内容,北方的《茉莉花》还唱古典戏剧《西厢记》中的主人公张生和崔莺莺的恋爱故事。尽管歌词内容相同,但各地流传的这首歌的旋律不同,各具特色。华北流行的曲调强调语言音调,具有叙事性;东北流行的音调铿锵有力,曲调转折颇多,表现了当地人粗犷刚强的性格特征。本书所介绍的这首是流行在长江下游的江苏省的《茉莉花》,当地流行的是被称为"吴侬软语",以委婉清俊的音调著称的汉语吴方言。这一地区在汉语中也被称为"江南",而江南民歌也以歌词含蓄优美,旋律清丽流畅、委婉妩媚而受到全国各族人民的喜爱。此曲是江南民歌的代表作,和其他江南民歌一样为单乐段的分节歌,结构均衡,但又有自己的特点。

Selected Well-known Chinese Songs
II. Folk songs (Ten Pieces)

by Chinese, Mr. Bellow "gave back the song in the original without any ornaments", adopting the same lyrics as those in *Zhui Baiqiu*, yet fewer ornaments to keep the song simple and lucid. After Mr. Bellow's book was published, many Western songbooks and music history publications introduced this folk song. Giacomo Puccini (1858–1924) adopted the melody of "Jasmine" and arranged it for a male chorus for his opera, *Turandot*. It has been well received by listeners all around the world and understood to be characteristic of Chinese music.

"Jasmine" is known almost everywhere in China. Apart from singing it, people adapted it for various instruments, including voice solos and ensembles. The lyrics in different regions are more or less the same in content: praising true love. For instance, "Jasmine" in the north of China tells the love story of Zhang Sheng and Cui Yingying in the classical drama *Romance of the Western Chamber*. Although the lyrics are similar to each other in different regions, the melody varies according to local flavor. Stressing the tone of the dialect, "Jasmine" in north China is narrative in its musical style while the song in the northeast part is sonorous and much varied in tune to give an expression of the character of its people. "Jasmine" recommend in this book is sung in Jiangsu Province, located in the lower reaches of the Yangtze River. This region is called Jiangnan, meaning "south of the Yangtze River", where Suzhou dialect is spoken and thought to be soft and gentle in tone, and pleasant to the ears. Charming and refined just as the dialect, Jiangnan folk songs are also liked all over China for their graceful lyrics and beautiful melodies with "Jasmine"

第一句围绕着全曲的主音"徵"（sol），以五声音阶级进为主，画出来两个波浪形的旋律线，第二句还是用五声音阶级进为主要旋法，落在徵音的下属音宫音（do）上。第一、二句分句清晰，其音乐风格具有十分明显的江南特征。第三句和第四句歌词连成一气，在音乐上也很难切断，句尾运用切分节奏，给人以轻盈活泼的感觉。

歌词：

好一朵茉莉花，
好一朵茉莉花，
满园花开香也香不过它。
我有心采一朵戴，
又怕看花的人儿骂。

好一朵茉莉花，
好一朵茉莉花，
茉莉花开雪也白不过它。
我有心采一朵戴，
又怕旁人笑话。

好一朵茉莉花，

being a representative of them. Like many other folk songs of the region, it is a single period song of several sections with a balanced yet distinguished structure. Around the keynote *zhi* (sol) of the song, raising the pentatonic scale, the first sentence draws two melodic lines in the shape of a wave, while the principle melodic progress still raises on the pentatonic scale. The second sentence ends on the *gong* note (do) which is the subdominant of *zhi* note (sol). Clearly divided, the first and the second sentences are characteristic of Jiangnan style, whereas the third and the fourth lines of the lyrics are strongly connected. The ending line has light and brisk syncopating rhythm.

Lyrics:

Beautiful jasmine,

Beautiful jasmine,

No other flowers in the whole garden is as fragrant as it.

I want to wear it in my hair,

But I am afraid to be scolded by the gardener,

If I pick it.

Beautiful jasmine,

Beautiful jasmine,

Snow is not as white as jasmine in bloom.

I want to wear it in my hair,

Yet I am afraid to be laughed at by others,

If I pick it.

Beautiful jasmine,

好一朵茉莉花,

满园花开比也比不过它。

我有心采一朵戴,

又怕来年不发芽。

Beautiful jasmine,

No other flowers in the garden is like it.

I want to wear it in my hair,

Yet I am afraid it won't bloom next year,

If I pick it.

美丽的茉莉花
Beautiful jasmine

康定情歌 ⑦ Kangding Love Song

扫码欣赏
Scan the code to appreciate

四川民歌
A folk song of Sichuan Province

二、民歌（10首）

李依若（1911—1959）
Li Yiruo (1911-1959)

《康定情歌》是20世纪30年代诞生于四川的一首民歌，其最初的作者是李依若（1911-1959）。李依若本名李天禄，四川省宣汉县人，他自幼聪慧，擅长诗歌，喜欢音乐。20世纪30年代，李依若在成都读大学时，与一个来自康定、李姓的姑娘恋爱。李依若与女友结伴到康定跑马山玩耍时，根据湘西民歌《溜溜调》编了《跑马调》，唱给女友听，以示求爱。这段姻缘后因家人反对，未能成功。但这首歌却被他的女友带回家乡康定，并在民间流传开来。因为康定是藏、汉杂居地区，所以在流传过程中，这首歌也带上了一些藏族民歌的风味。

民间流传的《跑马调》是由吴文季搜集到的。吴文季（1918-1966），福建惠安人，抗日战争期间就读于重庆青木关国立音乐学院声乐系。1941年，吴文季在康定参加了准备到缅甸作战的中国远征军，任文化音乐教员。这段时期他常漫步在康定，了解当地的民间音乐。一天，他在跑马山的山坡上休息，一位马夫哼唱的《溜溜调》吸引了他，他将这首歌记录下来，并为它加了一段歌词，命名为"跑马溜溜的山上"。回到重庆后，吴文季将歌词交给声乐老师伍正谦，伍正谦十分喜爱这首歌，便请作曲系的江定仙老师为其配钢琴伴奏以便演唱。江定仙配好伴奏后，将原名"跑马溜溜的山上"改为"康定情歌"，伍正谦在一次音乐会上演唱了它。抗日战争胜利后，江定仙又将此歌推荐给著名歌唱家喻宜萱。喻宜萱将其作为保留节目，从南京唱到了大西北，从国

Selected Well-known Chinese Songs
II. Folk songs (Ten Pieces)

"Kangding Love Song" is a 1930s folk song from Sichuan Province. Its earliest writer was Li Yiruo (born in Xuanhan County, Sichuan Province, 1911-1959), originally named Li Tianlu. A child prodigy, he was a good poet and loved music. When he was a college student in Chengdu in the 1930s, he fell in love with a girl of the Li family from Kangding. He wrote a song called "Running Horse Song" based on the "Liuliu Tune", a folk song in Western Hunan Province. The title of the song commemorated an excursion with Ms Li to the Running Horse Mountain in Kangding. However, the love affair had to be terminated due to the opposition of his parents. Yet the song he wrote for the girl, who took it back to her hometown, spread all over the area. As Kangding is an area inhabited by both Tibetan and Han people, the song exhibits some Tibetan musical elements.

"Running Horse Song" prevalent among the local people was collected by Wu Wenji (1918-1966), born in Huian, Fujian Province. He was a voice major at the National Conservatory of Music at Qingmuguan, Chongqing during the 1930s. When he was in Kangding in 1941, he joined the Chinese Expeditionary Force as a music instructor. During his stay in Kangding, he walked around to familiarize himself with the local folk music. One day, resting on the hillside of Running Horse Mountain, a ditty hummed by a horse keeper attracted him. After he took notes on the melody and added lyrics to it, he named it "On the Running Horse Mountain". Returning to Chongqing, he gave it to Wu Zhengqian, a vocal music teacher, who took a fancy to it and asked Jiang Dingxian, a teacher in the composition major to write the

内唱到了国外,使《康定情歌》传遍了世界。

2002年4月19日是喻宜萱在南京首演《康定情歌》55周年纪念日,甘孜藏族自治州特别给她颁发了纪念章,康定市也授予她"荣誉市民"的称号。

这首歌是由三个乐句组成的单乐段,其旋律流畅、优美、深情。歌曲的前两个乐句主要在中音区和高音区展开,情绪高昂、热烈;第三乐句是第二乐句的变化重复,从低音区开始,感情真挚,曲调委婉。歌词中加的衬词"溜溜的"和衬句"月亮弯弯",使全曲的节奏更活跃,旋律更舒展,情绪也更加风趣、生动。

歌词:

跑马溜溜的山上,一朵溜溜的云哟,
端端溜溜地照在康定溜溜的城哟。
月亮弯弯,康定溜溜的城哟。

李家溜溜的大姐,人才溜溜的好哟,
张家溜溜的大哥看上溜溜的她哟。
月亮弯弯,看上溜溜的她哟。

Selected Well-known Chinese Songs
II. Folk songs (Ten Pieces)

piano accompaniment for it. Jiang Dingxian renamed it "Kangding Love Song". Later Wu Zhengqian performed it in a concert. After the victory of anti-Japanese war, Jiang Dingxian recommended it to Yu Yixuan, a celebrated vocalist. She added it to her repertoires, and sang it on her tours all over the country and abroad.

On April 19th, 2002, on the 55th anniversary of Yu Yixuan's first performance of "Kangding Love Song" in Nanjing, the Garzi Tibetan Autonomous Prefecture issued her a commemorative certificate, and Kangding County presented her with an honorary citizenship.

Fluent, graceful and lively in its melody, the song is a single period made up of three sentences. Spirited and emotional, the melody of first two sentences moves between middle register and high register. Sincere in emotion and mild in tune, the third sentence, a variant repeating the second one, starts from a low pitch. The nonsense syllables, "liuliude" added as padding and "the moon is waning" added as lining, quicken the rhythm, making the song freer in melody, vivid and humorous in mood.

Lyrics:

A cloud on the top of the Running Horse Mountain,
Shines over Kangding town,
Oh, the moon is waxing, over Kangding town.

The eldest daughter of the Lis is so attractive,
That the eldest son of the Zhangs takes a fancy to her.
Oh, the moon is waxing, takes a fancy to her,

一来溜溜地看上人才溜溜的好哟,
二来溜溜地看上会当溜溜的家哟。
月亮弯弯,会当溜溜的家哟。

世间溜溜的男子,任我溜溜地爱哟,
世间溜溜的女子,任你溜溜地求哟。
月亮弯弯,任你溜溜地求哟。

Selected Well-known Chinese Songs
II. Folk songs (Ten Pieces)

Firstly because she is beautiful,

Secondly because she is good at housework,

Oh, the moon is waxing, good at housework.

All men in the world are for women to love,

All women in the world are for men to court.

Oh, the moon is waxing, for men to court.

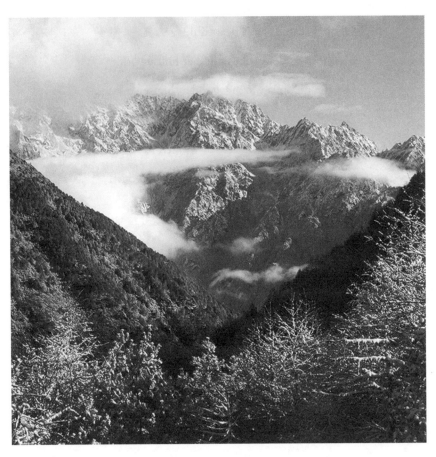

跑马山上一朵云
A cloud on the top of the Running Horse Mountain

小河淌水 ⑧ Bubbling Brook

扫码欣赏
Scan the code to appreciate

云南民歌
A folk song of Yunnan Province

旋律优美、曲调婉转的《小河淌水》是流行全国的云南民歌，表现了人们对美好生活的憧憬，其优美的旋律使人们联想到月亮、深山、森林中的清风和蜿蜒奔流的小河。

这首民歌最初名为《大田栽秧秧连秧》，是作曲家高梁（1919—2004）1943年在滇军18师艺工队工作时，根据一首流行在内蒙古鄂尔多斯高原的蒙古族民歌《蒙古小夜曲》的音调改编的，是一首动员青年人参军，投身到抗日战争中去的爱情歌曲。后来这首歌在云南民间流传开来，歌词也经过了改编。1947年，当时在云南大学读书的剧作家尹宜公听其友人华明邦演唱了这首歌，并把它记录了下来，起名为《月亮出来亮汪汪》。江骛又将其改为《小河淌水》，并发表在云南大学油印的《教学唱》第二辑《民歌专集》中。

Selected Well-known Chinese Songs
II. Folk songs (Ten Pieces)

Being a folk song of Yunnan popular throughout China, "Bubbling Brook" expresses people's beautiful dream of a good life. Its delightful melody reminds us of the moon, great mountains, refreshing breezes in the forest and winding brooks.

The song was originally named "Transplanting Rice Seedling in Fields". Gao Liang (1919–2004) adapted it from the tune of "Serenade of Mongolia", a folk song popular in the Ordos Plateau of Inner Mongolia in 1943 when he was employed at the Art Working Team of the 18th Division of the Yunnan Army. It was a love song meant to encourage young people to join the army to fight against the Japanese invasion. Later on, the song spread among the folks in Yunnan with altered lyrics. In 1947, Yin Yigong, a playwright, who at that time was a student at Yunnan University, recorded this song after hearing it sung by his friend Hua Mingbang and called it "A Bright Moon". Later, Jiang Wu renamed it "Bubbling Brook" and published it in a mimeographed book, *Folksong Album,* which was the second volume of *Teaching, Learning, and Singing* printed by Yunnan University in the same year.

20世纪50年代初，林之音和歌唱家黄虹又对这首歌进行了改编，填写了第二段歌词，并在北京和国外演唱，《小河淌水》飘洋过海，声名远播。1956年10月，云南人民出版社出版的《耍山调——云南民歌第一辑》中收录了这首歌，使其流传得更广，成为云南民歌的代表作。

《小河淌水》的歌词质朴自然，极富想象力。歌曲用"哎"开始，一声遥远的呼唤，仿佛从天边飘来，把听众带到了充满诗情画意的意境中：在银色的月光下，四周一片宁静，只有山下的小河发出潺潺的流水声。一位美丽的姑娘，见景生情，望月抒怀，把对情人的思念，倾注在优美的旋律中。

全曲由五个乐句组成，速度稍慢，节奏自由，从容舒展，曲调采用五声音阶羽调式，回环起伏、清新优美，具有云南地方特色。"哥啊，哥啊，哥啊！"是全曲的最高潮，柔情万千、情真意切，听之令人回肠荡气。

作曲家朱践耳曾将它改编为钢琴曲《流水》，作曲家孟贵彬、时乐濛将它改编为混声合唱。华裔俄罗斯作曲家左贞观还以这首歌为主题，创作过一出芭蕾舞剧。

Selected Well-known Chinese Songs
II. Folk songs (Ten Pieces)

In the early 1950s, Lin Zhiying and the vocalist Huang Hong adapted this song again by writing a second stanza. They performed the new "Bubbling Brook" in Beijing and abroad. Consequently, the song became widely known overseas. The song was published in *Singing Folksong, Vol. I Yunnan Folksongs* by Yunnan People's Publishing House in October, 1956. Since then it has become more widely known as a typical Yunnan folk song.

Although full of imagination, the lyrics of "Bubbling Brook" are simple and unadorned, starting with the calling word "hey", floating from afar, bringing the listeners into an idyllic moonlit pastoral scene, only the purling of a brook breaking the tranquility. Here a beautiful girl touched by the enchanting sight bursts out singing, offering her song to the one she loves.

Made up of five phrases with a lento tempo and untrammelled rhythm, the whole song unfolds slowly and leisurely. The *yu* mode of the pentatonic scale and a characteristic local color of Yunnan give the song a touch of softness and refreshing beauty. The words "ge a ge a (Oh, my dearest one! my dearest one!)" make the music reach the climax, touching the audience with tender feelings of true love.

Besides, Zhu Jianer adapted it into a piano piece entitled "Flowing Water". Meng Guibing and Shi Lemeng adapted the piece into a mixed chorus, and Zuo Zhengguan, a Russian Chinese composer wrote a ballet with the theme of this piece.

二、民歌（10首）

歌词：

哎！月亮出来亮汪汪亮汪汪，

想起我的阿哥在深山。

哥像月亮天上走天上走，

哥啊，哥啊，哥啊！

山下小河淌水清悠悠。

哎！月亮出来照半坡照半坡，

望见月亮想起我阿哥。

一阵清风吹上坡吹上坡，

哥啊，哥啊，哥啊！

你可听见阿妹叫阿哥？

Selected Well-known Chinese Songs
II. Folk songs (Ten Pieces)

Lyrics:

The moon comes out so brightly that

I think of my dearest one far away in the hills.

He is like the moon moving in the sky.

Oh, my dearest one! My dearest one!

At the foot of the hills the clear brook flows on.

The moon comes out above the slope,

Looking at it, I think of my dearest.

A breeze blows over the slope,

Oh, my dearest one! My dearest one!

Do you hear me calling you?

小河淌水
Bubbling brook

在那遥远的地方 ⑨ In a Distant Land

扫码欣赏
Scan the code to appreciate

哈萨克族民歌　王洛宾改编
A Kazak folk song, adapted by Wang Loubin

王洛宾（1913—1996）
Wang Luobin (1913-1996)

我国的哈萨克族有一百多万人，主要分布在新疆及甘肃一带。他们的语言属阿尔泰语系突厥语族，使用以阿拉伯字母为基础的文字。哈萨克族信奉伊斯兰教，大多从事畜牧业。哈萨克人酷爱音乐，他们的游牧生活又离不开马，谚语中有"歌和马是哈萨克人的两只翅膀"之说。《在那遥远的地方》是作曲家王洛宾（1913—1996）在1940年根据哈萨克族民歌《阿克芒代》（意为"洁白的前额"）改编的。这首歌的改编过程，包含着一个动人的故事。

王洛宾毕业于北京师范大学音乐系，抗日战争时期，曾在八路军领导的文艺团体西北战地服务团工作。1939年春天，他在甘肃河西走廊上的民乐县采风时，从当地哈萨克族同胞中搜集到了这首歌，但当时他不懂哈萨克语，便用汉语另外为它填了歌词，起名为《羊群中躺着想念你的人》。

在搜集到这首民歌后，王洛宾应著名电影导演郑君里的邀请到青海藏族牧区去拍电影，并在那里结识了当地藏族千户的女儿卓玛，美貌的卓玛和她那在草原上跃马扬鞭的身影令王洛宾倾倒，回到西宁后，他便根据《阿克芒代》的旋律进行改编，创作了《在那遥远的地方》这首歌。《阿克芒代》的旋律采用了欧洲调式体系中的混合利地亚调式，王洛宾在改编时，对原曲第一乐句的个别音符做了调整，保留了第二乐句的首尾两个小节，改写了第二和第三小节，保留了原民歌的调式。

Selected Well-known Chinese Songs
II. Folk songs (Ten Pieces)

Over a million Kazaks live in China, mainly in Xinjiang Uygur Autonomous Region and Gansu Province. The Arabic alphabet is used to write their language belonging to the Turkic branch of the Altaic language family. They are Moslems and most of them are engaged in animal husbandry. Kazaks are passionate about music and their nomadic life is inextricably tied to their animals, especially the horses. Hence one of their proverbs says that music and horses are the wings of the Kazaks. Based on a Kazak folk song, "Ak Mongdai (Snow White Forehead)", Wang Luobin (1913–1996), a composer, adapted the song in 1940 and called it "In a Distant Land". The song has a rather moving history.

Having graduated from the Music Department of Beijing Normal University, Wang Luobin worked for the Northwest Battlefield Troupe, a music organization, established in the 1930s. In the spring of 1939, he collected this song from a Kazak during his fieldwork in Minle County in the Hexi Corridor, Gansu Province. Since he did not understand Kazak language, he wrote Chinese lyrics of the song and named it "Missing You while Lying in a Flock".

Later, Wang and Zheng Junli, the famous film director, were shooting a film in the Tibetan plateau of Qinghai Province, where he got acquainted with Droma, the daughter of the local Tibetan leader. Wang was deeply impressed by her stunning beauty, especially when she was riding a horse, galloping over the grassland, swinging her whip. After returning to Xining, Qinghai's provincial capital, Wang wrote a song and gave it the title "In a Distant Land", using the melody of the Kazakh "Ak Mongdai" which had the mixolydian mode. Wang made adjustments of some notes of the first phrase of

二、民歌（10首）

　　1940年，王洛宾把《在那遥远的地方》作为插曲放在了他创作的轻歌剧《沙漠之歌》中，歌剧在西宁演出之后，这首歌便不胫而走，在这一带口头传唱开来。在流传的过程中，人们对其歌名和词、曲都进行了改造。歌名被群众改为《草原情歌》，歌词也有不少改动。如第三段歌词中的"我愿流浪在草原，给她去放羊"被改成"我愿抛弃了财产，跟她去放羊"，第四段中"我愿她拿着皮鞭"被改成"我愿她拿着细细的皮鞭"。在曲调方面，人们把歌中的"si"全部都改为降"si"，这样一来，第二乐句第三小节中的减五度音程就变成了纯五度音程，这样当然要好唱一些，但全曲的调式和调性都改变了，从欧洲调式体系中的混合利地亚调式变成了中国调式体系中的羽调式。

　　对于这些改动，王洛宾并不同意。关于歌名，他认为还是叫"在那遥远的地方"好，关于歌词，他曾经说过："选择细细的皮鞭的想法是多余的，如果你能抛弃了财产跟她去放羊，鞭子的粗细早已不是考虑的问题。"关于曲调，他认为还是他的改编在调式上更接近原来的民歌，更有哈萨克族的民族风格，也更具美感。

　　青海一带流行秦腔，秦腔的唱腔分男腔和女腔，如果根据男腔的曲调创作相应的女腔，通常是把男腔的曲调移高四度或五度后，对曲调进行一些调整。这种办法叫"反调"或"翻调"，是我国民间器乐和戏曲音乐常用的曲调发展手法。"反调"以后的旋律和原调比较会有一定程度，甚至是较大的变化，还可能因此

the original song, kept the beginning and ending of the second phrase and recomposed the second and third bars. However, the original mixolydian mode of the folk song was retained.

In 1940, Wang composed a light opera called "Song of the Desert", and he used this song as an interlude. Not long after, the opera was put on in Xining and the song spread far and wide around the area of Xining. As it circulated, its title, words, and music underwent further changes. People renamed it "Love Song of the Grassland" and changed some of the lyrics. For instance, the original words in the third stanza "I would like to go to grassland and to be her shepherd" were replaced by "I would give up my property and become a shepherd with her". In the melody, ti was also changed into ti flat to make it easier to sing. In this way the diminished fifth turned into the perfect fifth. With the mode and tonality of the original song totally altered, it was converted from the mixolydian mode into the Chinese *yu* mode.

Wang Luobin didn't accept these modifications and insisted on keeping the original title "In a Distant Land", and he held that his version was closer to the original mode of the Kazak folk song, therefore more beautiful.

In Qinghai where Wang Luobin got the inspiration to write the song, Shaanxi opera is very popular. Two kinds of melodies exist: one for the male voice and the other for the female voice. The melody for the female voice is based on the male melody with its pitch raised fourth or fifth higher and some tune adjustments. This method is called

衍生出新的乐曲。会唱秦腔的人，许多都会运用这种手法，把一段男腔改变为女腔，或者反过来，把一段女腔改变为男腔。京剧与其他许多戏曲中大、小嗓和正、反调曲调的关系，其实都是用"反调"的手法创作出来的，京剧的基本调二黄和西皮，经"反调"后，便变化派生出反二黄和反西皮。

《草原情歌》在民间流传过程中，又有人把它的曲调当作男腔，运用了秦腔中的"反调"手法，将其改编成了女腔，改编后的曲调为羽调式，比原来翻高了五度。这样，除了王洛宾改编创作的《在那遥远的地方》外，民间还流行与《在那遥远的地方》不同的《草原情歌》和用"反调"手法对《草原情歌》进行改编创作的"女腔"曲调。

王洛宾后来到新疆工作，搜集、记录、整理了数十首各少数民族的民歌，如乌孜别克族民歌《半个月亮爬上来》《掀起你的盖头来》，维吾尔族民歌《青春舞曲》《达坂城的姑娘》，哈萨克族民歌《阿拉木汗》《可爱的一朵玫瑰花》《玛依拉》等，它们在国内外广为流传。

《在那遥远的地方》是王洛宾传唱最广的歌，也是全世界传唱最广的中国歌曲之一。

fandiao (turning the tune over), which is a commonly used technique of melodic development in Chinese traditional instrumental folk music and opera music. Sometimes the female tune is changed so much as to result in a completely new musical composition. Talented Shaanxi opera singers can use this method of turning a piece of a male melody into a female one or vice versa. Actually many tunes of Beijing opera or other regional operas are all created by using this method.

In the process of spreading among local folks, some people used the *fandiao* method, turning "Love Song of the Grassland" from male *qiang* to female *qiang*, which is of *yu* mode with its pitch raising five degrees higher than the original one. As a result, another melody appeared besides "In a Distant Land" adapted by Wang Luobin. People called it "Love Song of the Grassland" which was different from "In a Distant Land". Still different is another version of "Love Song of the Grassland" which is sung in female *qiang* after being changed with the *fandiao* method.

In Xinjiang, Wang collected and recorded dozens of minority folk songs. For example, there are Ozbek folk songs "A Crescent Moon Is Rising" "Unveil Your Bridal Veil", Uyghur folk songs "Dance of the Youth" "The Girl from Dabancheng", and Kazak folk songs "Almixan" "A Lovely Rose and Mayila". All these songs are popular both at home and abroad.

Not only popular in China, "In a Distant Land" by Wang Luobin is also one of the Chinese songs popular in the world.

二、民歌（10首）

歌词：

在那遥远的地方，
有位好姑娘。
人们经过她的帐房，
都要回头留恋地张望。

她那粉红的小脸，
好像红太阳。
她那活泼动人的眼睛，
好像晚上明媚的月亮。

我愿抛弃了财产，
跟她去放羊。
每天看着她粉红的小脸
和那美丽金边的衣裳。

我愿做一只小羊，
跟在她身旁。
我愿她拿着细细的皮鞭，
不断轻轻打在我身上。

Selected Well-known Chinese Songs
II. Folk songs (Ten Pieces)

Lyrics:

In a distant land

There lives a good girl.

People passing her tent

Look back and sigh.

Her little rosy cheeks

Look like the rising sun.

Her lively flashing eyes

Are like the moon at night.

I want to leave all behind

And be a shepherd alongside her,

So as to look at her little rosy cheeks every day

And her beautiful gold-laced gown.

I wish to be a lamb

Walking by her side,

And have her small playful whip

Gently stroke my back.

美丽的哈萨克族姑娘
A beautiful Kazak girl

达坂城的姑娘 ⑩ The Girl from Dabancheng

扫码欣赏
Scan the code to appreciate

维吾尔族民歌　王洛宾改编
A Uygur folk song, adapted by Wang Luobin

中国名歌选萃
二、民歌（10首）

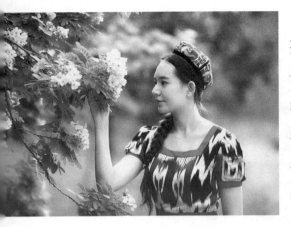

维吾尔族有八百多万人，主要居住在新疆维吾尔自治区，维吾尔语属于阿尔泰语系突厥语族，维吾尔文用阿拉伯文字母拼写。维吾尔族人能歌善舞，民间流行着称为"木卡姆"的12套歌舞音乐。《达坂城的姑娘》是一首著名的维吾尔族歌舞曲。

"达坂"在维吾尔语中意为"山坡"，达坂城坐落于吐鲁番盆地边缘，是位于乌鲁木齐和吐鲁番之间的一个小镇。这个小镇因为这首歌驰名中外，成为新疆旅游的热门景点之一。

这首歌舞曲民歌原来叫"达坂城"，并没有姑娘两个字，是经过王洛宾搜集整理后才流行全国的，而这首民歌的搜集过程也颇具传奇色彩。

1938年4月，王洛宾作为西北战地服务团的一员，随团到兰州宣传抗日，当时有许多从苏联运送援助中国抗战物资的车队路经兰州，车队的司机中有不少维吾尔族和哈萨克族人。1939年的一天，西北战地服务团在兰州西关十字车站举行欢迎车队到达兰州的联欢会，一位维吾尔族司机即兴唱了《达坂城》。那特殊的曲调和韵律，使王洛宾震惊，会后，王洛宾专门去向那位司机求教，记下了乐谱，还请在兰州卖葡萄干的维吾尔族商贩翻译了歌词。

Selected Well-known Chinese Songs
II. Folk songs (Ten Pieces)

"The Girl from Dabancheng" is a Uygur folk song from Xinjiang Uygur Autonomous Region, the home of over eight million Uygurs. Their language belongs to the Turkic branch of the Altaic family written in the Arabic alphabet. Uygurs are good at singing and dancing. "The Mukam", a song-dance music made up of twelve sets of singing and dancing pieces, is popular among the Uygurs. "The Girl from Dabancheng" is one of the most well-known Uygur dancing songs.

"Daban" means hillside in the Uygur language. Although it is a small town seated at the border of the Turpan Basin between Urumqi and Turpan, Daban Town is a favorite tourist destination due to the popularity of its music.

The song was originally named "Dabancheng" without the word "girl" in it. It was after Wang Luobin collected and rearranged it that the song became well known all over the country. How he did it is quite legendary.

In April, 1938, Wang Luobin came to Lanzhou City, Gansu Province. At that time Lanzhou was a thoroughfare for many motorcades. Among the motorcade drivers there were many Uygurs and Kazaks. One day in 1939 one of the Uygur drivers sang an impromptu song called "Dabancheng" at a party welcoming the motorcade to Lanzhou. Wang was deeply impressed by the unique melody and rhythm, and he transcribed the music and lyrics and asked a Uygur vendor selling raisins in Lanzhou to translate the lyrics into Chinese.

那天晚上，王洛宾兴奋得久久不能入睡，连夜加工整理，一遍遍地修改，几易其稿，最后将词曲确定下来，并命名为"达坂城的姑娘"。第二天，在欢送车队离开兰州的联欢会上，王洛宾登台演唱了《达坂城的姑娘》，并配以刚学来的维吾尔族舞蹈动作，受到观众的热烈欢迎，这首歌立即不胫而走，传遍了兰州的大街小巷。

王洛宾的朋友赵启海，在王洛宾处获得这首歌后，把它从兰州带到了重庆，随后这首歌又传到了昆明和东南亚的一些国家。

歌词：

达坂城的石路硬又平啊，

西瓜大又甜呀，

达坂城的姑娘辫子长啊，

两个眼睛真漂亮。

你要想嫁人

不要嫁给别人，

一定要嫁给我，

带着你的嫁妆，

领着你的妹妹

赶着那马车来。

Selected Well-known Chinese Songs
II. Folk songs (Ten Pieces)

Wang Luobin was too excited to fall asleep that night. He stayed up late to work on the song, trimming and modifying it again and again. He wrote several drafts before settling on the final version of the music and lyrics. He named the new song "The Girl from Dabancheng". The next day at the farewell party for the motorcade returning to Xinjiang, he sang the song on stage, and accompanied his singing with a Uygur dance he had just learned. He got an ovation from the audience. Soon afterwards the song became a big hit on the streets of Lanzhou. Zhao Qihai, a friend of Wang Luobin's, took the song to Chongqing, and from there it was spread to Kunming and some countries in Southeast Asia.

Lyrics:

The stone road in **Dabancheng** is smooth and firm.
Big and sweet are the watermelons there.
The girl from **Dabancheng** has long braids.
And two beautiful eyes.

If you want to marry, marry only me.
You must wed me!
Bring your dowry, bring your bridesmaids,
Drive your cart and come to me.

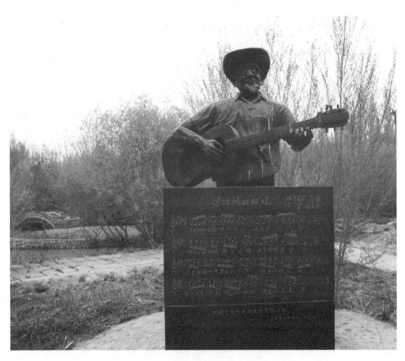

达坂城王洛宾塑像
Statue of Wang Luobin at Daban Town

乌苏里船歌 ⑪ Ussuri River Shanty

扫码欣赏
Scan the code to appreciate

赫哲族民歌　汪云才、郭颂改编
A Hezhen folk song, adapted by Wang Yuncai and Guo Song

中国名歌选萃
二、民歌（10首）

《乌苏里船歌》是一首充满生活气息的赫哲族民歌。赫哲族人口较少，只有四千多人，主要分布在黑龙江省同江、抚远和饶河等市、县的沿江地区。赫哲族居住的三江平原和完达山一带，景色壮丽、河流交织、江流宽稳、土壤肥沃。三江口盛产各种鱼类，以大马哈鱼最为著名。完达山余脉蓊郁蜿蜒于虎林、饶河等县境内，山上有茂密的森林，林中栖息着各种珍禽异兽，从远古时代起，就是天然渔场和逐猎之地。除了从事捕鱼外，赫哲人还从事狩猎业。赫哲族热爱音乐、善于歌唱，人口虽少，民间音乐却非常丰富多彩，主要有民歌、说唱音乐"伊玛堪"等。

赫哲族的民歌称为"嫁令阔"，歌词多为即兴编唱，也可以不用实词而只用特有的衬词"赫尼那""啊拉赫尼那"等来唱。演唱传统的"嫁令阔"时，经常在实词之前加一段用散板唱的虚词当作引子。"嫁令阔"的曲调婉转悠扬，常用于歌颂爱情和美丽的大自然，抒发对家乡的山河、风光、沃土、旷野的无限热爱，有渔歌、猎歌、情歌、悲歌等题材，其中以情歌居多。

"伊玛堪"是一种以说为主、以唱为辅的说唱形式，以表现历史故事、英雄事迹、神话传说和爱情故事为主要内容。"伊玛堪"由一人说唱，赫哲人尊称说唱"伊玛堪"的人为"依玛堪乃依"，意为聪明智慧的人。说唱"伊玛堪"不用乐器伴奏，曲调相当丰富。

"Ussuri River Shanty" is a lively Hezhen folk song. Being the comparatively small population of over four thousand, the Hezhen people live mostly along riverside regions of Tongjiang, Fuyuan, and Raohe in Heilongjiang Province. The Three Rivers Plain and the Wandashan Mountain areas inhabited by the Hezhen are beautiful and fertile with wide intertwining rivers. It is an area rich in fish, especially salmon. The forest-covered ridge winding through Hulin and Raohe counties of Wandashan Mountain is home to many rare birds and animals. Since ancient times, it has been a natural fishing and hunting ground. Living in such a beautiful and rich place, engaging in fishing as well as hunting, the Hezhen love music, and are quite good at singing. Small in population, they have rich colorful folk songs and ballad singing, called *yimakan*.

The Hezhen folk song is called *jialingkuo* with improvised lyrics. Performing the traditional *jialingkuo*, the singer will start with meaningless words like "henena", "alahenena" as a prelude in free rhythm before content words. The music of *jialingkuo* is melodious and expresses the Hezhen people's love for their hometown, their rivers and mountains. The lyrics deal with the subjects of fishing, hunting, love, and sorrow. However, love songs are by far the most numerous.

Being a kind of ballad singing performance, the major part of *yimakan*, is a recitative, with singing taking the second place. The subjects are history, sagas, legends, or love stories. *Yimakan* is a solo, performed by a person called *jimakanaiyi*, meaning "a man of

有苍劲悲壮的"老翁腔",也有委婉轻柔的"少女调",还有"欢乐调""悲调""叙述调"等。"伊玛堪"的曲调比较自由,一般由两个乐句构成,乐句长短不一,根据歌词的音节数多少而定,所以曲调的结构不方整,节拍多变。旋律根据故事情节的变化而发展,一段唱的开始部分和结尾部分的旋律性比较强,而中间部分则因突出叙述故事,具有吟诵的性质。

《乌苏里船歌》是汪云才和郭颂根据赫哲族民间音乐的曲调加以改编而成的,包括序唱、主体和尾声三个部分。第一部分序唱用虚词演唱,其旋律根据"伊玛堪"的散板性引子改编,"阿郎—赫尼那"的呼唤和接下来的回声模仿,把听众带到了宽阔的乌苏里江面之上;两小节跌宕起伏的引子,描写一叶扁舟在荡漾的碧波中缓缓漂来,赫哲族渔民傲立船头,引吭高歌。第二部分是歌曲的主体,朴实明快地表现了赫哲族渔民对新生活和祖国山河的由衷赞美。这一部分的旋律是根据流传很广的"嫁令阔"情歌《狩猎的哥哥回来了》改编的,曲调抒情甜美,活泼开朗,表现了一位赫哲族姑娘迎接情人狩猎归来的喜悦心情。旋律呈"浪谷式"线条,由连续级进和上、下行大跳结合构成,恰似水中波浪,起伏跌宕。第三部分是用"伊玛堪"改编的散板性的尾声,描写满载鱼虾的小船渐渐远去,与第一段相呼应,仍只用虚词。全曲充满诗情画意,有鲜明的民族风格和时代特色。

wisdom". No instruments are used for *yimakan*. However, *yimakan* has a variety of melodies ranging from the vigorous and grieving old man aria, to the joyful tune, the sorrowful tune and the narrative tune, to the graceful and soft young girl's melody. Generally speaking, the music of *yimakan* is rather free, which is made up of two phrases with different lengths, depending on the syllables of the lyrics. That's why the structure and the rhythm of its music are various. And its melody alters with the storyline. Usually the beginning and the ending parts are melodic while the middle part is a narrative-like chant telling the story.

Based on a Hezhen folk song and adapted by Wang Yuncai and Guo Song, "Ussuri River Shanty" consists of three parts: the prelude, the main body, and the coda. The first part is sung in meaningless words, the melody adapting the free rhythm of *yimakan*'s prelude. Starting with the calling words, "alang-henena", followed by the sound of imitated echoes, the rhythmic ebb and flow of the prelude is made up of two sections. The melody brings listeners to the wide Ussuri River and describes a slowly returning fishing boat on the rippling blue waves. A Hezhen fisherman is standing proudly on the ship's prow and singing loudly. The second part is the main body of the song, simple and lively, expressing the Hezhen people's pride in their motherland. Its melody was adapted from a popular *jialingkuo* love song called "My Hunting Brother Is Returning". Sweet, lyrical, lively and cheerful, the music of the original song depicts a Hezhen girl's joy when she meets her lover coming back from a hunt. Just like the waves of the river's

二、民歌（10首）

1980年，《乌苏里船歌》被联合国教科文组织作为中国民歌的代表作选为亚太地区音乐教材。

歌词：

乌苏里江来长又长，
蓝蓝的江水起波浪。
赫哲人撒开千张网，
船儿满江鱼满舱。

白云飘过大顶子山，
金色的阳光照船帆。
紧摇桨来掌稳舵，
双手赢得丰收年。

白桦林里人儿笑，
笑开了满山红杜鹃。
毛主席领上幸福路，
人民的江山万万年。

ceaseless undulation, the melody presents a series of alternating "ridges and valleys" and combines continuous rises, jumps, and leaps. The third part is the coda, a free rhythm adaptation from *yimakan*. Here we see a boat loaded with fish and shrimp fading into the distance. Echoing with the first part, it uses only meaningless words. Idyllic and poetic, the song shows a distinctive style of Hezhen folk songs, characteristic of the times.

Chosen as a representative work of Chinese folk songs by UNESCO in 1980, "Ussuri River Shanty" became one of the songs in a music textbook of the Asia-Pacific Region.

Lyrics:

Along the Ussuri River wide and long,

Blue waters are rippling.

Hezhen throw out a thousand fishing nets,

From a thousand boats to fill their boats.

White clouds are flying over Dadingzi Mountain,

Golden sunshine colors our sails.

Hold the helms steady and row the boat quickly,

Let's take the harvest with our hands.

Laughter fills the birch woods,

Azaleas in the mountain are in bloom.

Chairman Mao leads us to a happy life,

Long live the people's country and our motherland.

乌苏里江上的渔船
A fishing boat on the Ussuri River

龙 船 调 ⑫ A Dragon Boat Tune

扫码欣赏
Scan the code to appreciate

土家族民歌
A *Tujia* folk song

《龙船调》是一首著名的土家族民歌。土家族自称"毕兹卡",现有八百多万人,主要分布在湖北和湖南两省的西部和重庆市的酉阳、秀山、彭水等县。土家族主要从事农业生产,主要作物有稻谷、玉米、小麦及各种杂粮。

土家族的语言属汉藏语系藏缅语族,无本民族文字,通用汉文。土家族崇信万物有灵,并供奉祖先,主要神灵有猎神、土地神、阿密妈妈、四官神等。土家族的巫师叫"梯玛",职责是主持祭祀、婚丧礼仪及驱鬼除病。"梯玛"为世袭。

土家族民歌分别用汉语和土家语演唱。用汉语唱的土家族民歌数量多、分布面积广,主要有小调、山歌、号子、灯调、薅草锣鼓、婚礼歌等。

农历正月十五是中国传统的灯节,届时土家族地区家家户户张灯结彩,并跳秧歌、划旱船,以示庆祝。在庆祝灯节时演唱的歌曲称为"灯歌"或"灯调"。《龙船调》便是一首湖北利川市一带用汉语唱的土家族灯歌,原名《种瓜》,又叫《瓜子仁调》,由一男一女表演,女的扮演要过河去亲戚家拜年的小姑娘,男的扮演热心推船渡河的艄公。1957年,当地民间艺人汪国盛、张顺堂在全国第二届音乐舞蹈会演中表演了这首歌,并录成唱片。由于这首歌旋律洗练简洁、充满变化、优美动听、情趣盎然,很

Selected Well-known Chinese Songs
II. Folk songs (Ten Pieces)

"A Dragon Boat Tune" is a famous *Tujia* folk song. *Tujia* people call themselves *bizika*. Their population is over eight million. Most of them live in the western part of Hubei and Hunan provinces and in Youyang, Xiushan, Pengshui and other counties of Chongqing, engaged mainly in growing rice, corn, wheat, and other grains.

The *Tujia* use Chinese characters to write their language which belongs to the Tibeto-Burmese branch of the Sino-Tibetan language family. *Tujia* people are animists who also warship their ancestors. The god for hunting, the god for land, Ami Mum and Four Officer God are the main deities in their belief system. *Tujia* shaman is called *tima*, who is in charge of hosting the worship ceremonies as well as other ceremonies such as weddings, funerals and ceremonies for driving off demons. The position of *tima* is hereditary.

Tujia folk songs are sung in Chinese and *Tujia* language respectively. Songs in Chinese are more numerous, and are mainly of ditties, mountain songs, working songs, lantern songs, gongs and drum songs, and wedding songs.

The fifteenth day of the first month of the lunar calendar is the traditional Chinese Lantern Festival. On that day people hang up lanterns and put up decorations, and they perform the *yangge* dance (a popular rural folk dance) and land boat dance to celebrate while singing lantern songs. Sung in Chinese, "A Dragon Boat Tune" is one of the lantern songs popular in Lichuan, Hubei Province. Originally it was called "Planting Melons" or "Melon Seeds Tune" performed by a girl and a man with the latter playing the part of a warm-hearted

快便流传开来,受到全国各族人民的喜爱。1983年,它曾被联合国教科文组织评为世界上最优秀的25首民歌之一。

《龙船调》之所以有很强的艺术感染力,主要在于它词曲都很有特色。歌中描绘了一个活泼俏丽的小姑娘"妹娃"请老艄公摆渡过河的一幅鲜明生动的画面。它的歌词精练,具有浓郁的生活气息,表现了土家族姑娘的娇羞、妩媚,以及老艄公幽默风趣的性格。

它的曲调以sol为主音,是中国传统音乐中的徵调式。开始处的两个乐句在高音区展开,自由高亢,有山歌风味,接下来旋律围绕着la进行,并用划船的节奏,使曲调具有舞蹈性。这首歌的音域较宽,旋律流畅,起伏较大,优美动人,节奏较自由,演唱中两个演员互相对答,衬词富有情趣,有时还半说半唱,加强了音乐的感染力,增添了生活气息和抒情性。

歌词:

正月是新年,妹娃去拜年。

(女白)妹娃要过河哇,哪个来推我嘛?

Selected Well-known Chinese Songs
II. Folk songs (Ten Pieces)

boatman, the former playing the role of a little girl who wants to cross the river to pay a New Year's visit to her relatives. Native entertainers Wang Guosheng and Zhang Shuntang performed this song at the Second National Music and Dance Festival in 1957, and later it was made into a phonographic record. Since its melody is pithy, unsophisticated and full of changes and exuberant vitality, it spread quickly and became loved by people of all ethnic groups in China. It was listed as one of the top 25 folk songs worldwide in 1983 by UNESCO.

"A Dragon Boat Tune" has a strong artistic appeal due to its music and simple lyrics. Immersed in local life, its succinct words depict the enchanting *Tujia* girl and the humorous old boatman.

Sol is the tonic of the song which is the *zhi* mode of traditional Chinese music. Free and sonorous, the first two phrases of the song are unfolded in treble of a mountain song. The following melody, easy to dance to, is mainly around la in a rhythm of rowing a boat. With a comparatively wide range of music, fluent and rippling in melody, free and appealing in rhythm, the song is filled with an atmosphere of life and feelings in a half sung and half spoken musical dialog.

Lyrics:

In the first month of the lunar year is the New Year Festival,
I am the little sister and I am going to pay a New Year call.

（男白）我就来推你嘛!

（男白）我就来推你嘛!

艄公你把舵扳哪,

妹娃我上了船,将妹娃推过河哟喂!

三月里是清明,妹娃去踏青。

（女白）妹娃要过河哇,哪个来推我嘛?

（男白）还是我来推你嘛!

艄公你把舵扳哪,

妹娃我上了船,将妹娃推过河哟喂!

Selected Well-known Chinese Songs
II. Folk songs (Ten Pieces)

Girl (speaks): Little sister wants to cross the river, who will ferry me?

Boatman (speaks): I will ferry you.

Boatman please steer your boat,

Little sister has boarded the boat.

Please ferry me across the river.

In the third month of the lunar year is the Qingming Festival,

I am the little sister and I am going to have an outing.

Girl (speaks): Little sister wants to cross the river, who will ferry me?

Boatman (speaks): I will ferry you again.

Boatman please steer your boat,

Little sister has boarded the boat.

Please ferry me across the river.

土家妹子要过河
Tujia girl wants to cross the river

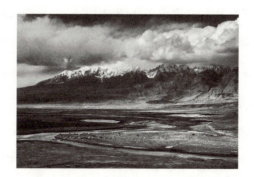

花儿为什么这样红 ⑬ Why Is the Flower So Red

扫码欣赏
Scan the code to appreciate

塔吉克族民歌　雷振邦改编
A Tajik folk song, adapted by Lei Zhenbang

《花儿为什么这样红》是电影《冰山上的来客》的插曲。这部电影是我国赫哲族剧作家乌·白辛的作品,描写了1951年夏天,西部边疆萨里尔山的驻军识破敌特的阴谋,一举消灭敌人的故事,是一部具有鲜明的民族特色和地域色彩的反间谍影片。《花儿为什么这样红》是这部电影中的一首插曲,表现了一名驻守在帕米尔高原的边防军战士阿米尔,同当地一名美丽的姑娘古兰丹姆的浪漫爱情。这首歌是雷振邦根据塔吉克族民歌《古丽碧塔》改编而成的。由于它具有浓郁的塔吉克族风格,旋律委婉动听,感情真切深沉,1963年影片公演后即在全国广泛流传开来。

塔吉克族有40多万人,主要聚居在位于帕米尔高原东部的新疆塔什库尔干塔吉克自治县。塔吉克人信仰伊斯兰教,语言属印欧语系伊朗语族东部语支。塔吉克人无本民族文字,通用维吾尔文。塔吉克族有悠久的历史,其族源可追溯到古代在帕米尔高原东部操东部伊朗语的诸语落。塔吉克族的民歌内容丰富、题材多样,主要采用波斯—阿拉伯音乐体系,多为哈贾兹、库尔德、拉斯特、阿吉姆和努哈万德调式。在节奏方面,塔吉克族民歌除采用二拍子、三拍子和四拍子外,也采用五拍子和七拍子。

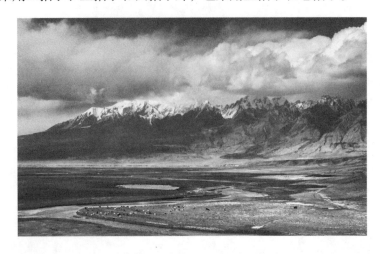

"Why Is the Flower So Red" is an interlude of the feature film *Visitors to the Icy Mountains* written by Wu Baixin, a Hezhen dramatist. "Why Is the Flower So Red" is about a romantic love story between Amir, a frontier soldier in the Pamir Mountains and Gurandanm, a beautiful local Tajik girl. The song was adapted by Lei Zhenbang from the Tajik folk song, "Guli Bita". Because of its ethnic characteristics of Tajik people, its beautiful melody and the deep feelings expressed, the song became popular all over the country in 1963.

The population of Tajik nationality is over 400,000. Most of them live in Tashkulkent Autonomous County of Xinjiang, eastern part of the Pamirs. They are Moslem and their language belongs to east Iranian branch of Indo-European family. They use the Uygur writing system. The Tajik nationality has a long history dating back to those ancient tribes who lived in the east part of the Pamirs and spoke the eastern Iranian language. Tajik folk songs are rich and eclectic in their content. The music is mainly the Persian-Arab music system of which the hajaz, the kurd, the rest, the agim and the nuhawand modes are most common. Tajik folk song rhythms use two, three, four and sometimes five and seven beats.

二、民歌（10首）

《古丽碧塔》是一首采用哈贾兹调式的传统塔吉克族民歌，据说古丽碧塔是古代生活在阿富汗喀布尔城中的一位十分美丽的贵族小姐。一位在丝绸之路赶脚的中国塔吉克族青年爱上了她，因这位青年出身卑微，遭到了古丽碧塔父母的反对，他只能顺着古丝绸之路流浪，用这首优美的歌，表达他的爱情。

雷振邦（1916—1997）是满族作曲家，曾长期在长春电影制片厂工作，他写的电影音乐常用民间音乐素材构成音乐主题，具有浓郁的民族风格和地区特色。雷振邦在改编这首歌时强调了旋律中的增二度进行，并用歌词重复的手法，加强了语气，使曲调更加深情。

歌词：

花儿为什么这样红？
为什么这样红？
红得好像燃烧的火，
它象征着纯洁的友谊和爱情。

花儿为什么这样鲜？
为什么这样鲜？
鲜得使人不忍离去，
它是用了青春的血液来浇灌。

Selected Well-known Chinese Songs
II. Folk songs (Ten Pieces)

Written in hajaz mode, "Guli Bita" is a traditional Tajik folk song. It is said that "Guli Bita" was a beautiful aristocratic young lady living in Kabul, Afghanistan in ancient times. A young Tajik man, who was a porter working along the Silk Road, fell in love with her. Because of his humble origin, the girl's parents objected to the young man. He could only wander along the ancient Silk Road, singing this beautiful song to express his lost love.

Lei Zhenbang (1916–1997) was a Manchurian composer who worked with Changchun Film Studio. He was known for using folk materials as theme for many of his music written for film. In adapting "Why Is the Flower So Red", he emphasizes the interval of augmented second in its melody and by repetition of some words, he strengthens the tone and deepens the feelings expressed.

Lyrics:

Why is the flower so red?

Why is it so red?

As red as a burning fire,

It's the symbol of the real friendship and true love.

Why is the flower so fresh?

Why is it so fresh?

So fresh that one cannot bear to part with it,

It must be watered by blood of youthfulness.

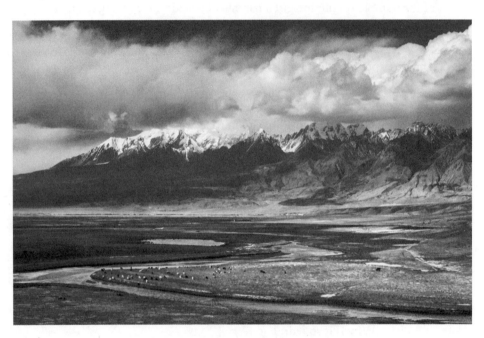

帕米尔高原风光
The scenery of Pamirs

敖包相会 ⑭ Rendezvous at an Obo

扫码欣赏
Scan the code to appreciate

蒙古族民歌　通福改编
A Mongolian folk song, adapted by Tongfu

二、民歌（10首）

蒙古族是我国民族大家庭中一个历史悠久、勤劳勇敢的少数民族，有五百多万人，主要居住在内蒙古自治区和东北三省。蒙古语属阿尔泰语系蒙古语族，我国境内有内蒙古、卫拉特、巴尔虎—布利亚特三种方言。蒙古族有优秀的文化传统，民间音乐十分发达。蒙古族民歌分为长调和短调两类，其中的长调是中国民歌中著名的品种，它在2005年被联合国教科文组织列为"人类口头和非物质遗产代表作"。《敖包相会》是达斡尔族作曲家通福根据内蒙古东部呼伦贝尔大草原上的一首古老的短调民歌改编创作的。

敖包又叫鄂博，在蒙古语中意为"堆子"，敖包最早是草原上用作道路或界域的标志，后来演变成为祭祀山神和路神的地方。敖包一般是堆石成台，在沙漠中则用柳条堆成。蒙古族牧民们每年在6、7月间祭祀敖包，仪式结束后，还好举行传统的赛马、射箭、摔跤、唱歌、跳舞等娱乐活动。姑娘和小伙子则借此机会躲进草丛里，谈情说爱，互诉衷情，这就是敖包相会。蒙古族在古代曾信仰萨满教，萨满教具有自然崇拜、图腾崇拜和始祖崇拜的特点，而祭敖包是以大自然崇拜为目的，因此，祭敖包源于原始的信仰，是一种历史悠久的文化形态。

Selected Well-known Chinese Songs
II. Folk songs (Ten Pieces)

In the big family of China's nationalities, the Mongol are industrious and brave with a long history. There are over five million Mongols, most of whom live in the Inner Mongolia Autonomous Region and other three northeast provinces of Heilongjiang, Jilin and Liaoning. The Mongol language belongs to the Mongolian branch of Altaic language family. In China, there are three Mongol dialects: the Inner Mongolian, the Oirad and the Buriat dialects. The Mongol nationality has an illustrious cultural tradition, among which, folk music is very rich. Mongolian folk songs are divided into the long tune and the short tune. The long tune is a variety of Chinese folk songs and it was listed as the Representative Work of Human Oral and Intangible Cultural Heritage by UNESCO in 2005. "Rendezvous at an Obo" is adapted by Tongfu, a Daur composer, from an old folk song of the short tune popular in Hulunbuir grassland in the eastern part of Inner Mongolia.

An obo means "mound" in Mongolian, used in ancient times to mark a road or a boundary. Gradually, it became a place to worship the god of mountains and roads. Usually an obo is made of stones. In desert areas willow twigs are used to make an obo. Every year in June or July, Mongolian herdsmen hold an obo worship ceremony. After the ceremony, there are traditional recreational activities, such as horse racing, archery, wrestling, singing and dancing. Young men and women will take the opportunity to hide in the tall grass expressing their affections for each other. This is what has been described as rendezvous at obo. Historically Mongolians practiced shamanism which can be characterised also by nature worship, totem worship and

《敖包相会》是电影《草原上的人们》的插曲,该片是长春电影制片厂在1952年拍摄的,剧本由蒙古族作家玛拉沁夫所作,音乐由达斡尔族作曲家通福(1919—1989)创作。这首歌具有蒙古族民间音乐的风格和特色,旋律豪迈爽朗,舒展开阔,抒发了恋人间纯朴真挚的感情。1953年电影上映后,《敖包相会》也随之传遍了全国,至今为各族人民所喜爱。

歌词:

(男)十五的月亮升上了天空哟,
　　　为什么旁边没有云彩?
　　　我等待着美丽的姑娘呀,
　　　你为什么还不到来哟嗬?

(女)如果没有天上的雨水呀,
　　　海棠花儿不会自己开。
　　　只要哥哥你耐心地等待哟,
　　　你心上的人儿就会跑过来哟嗬。

Selected Well-known Chinese Songs
II. Folk songs (Ten Pieces)

ancestor worship. The worship at an obo is a form of nature worship that looks back upon a long history.

"Rendezvous at an Obo" is the interlude of the movie *People on the Grassland* which was produced by Changchun Film Studio in 1952. The script was written by Malaqinfu, a Mongolian writer. The music was composed by Tongfu (1919–1989), a Daur composer. The piece has the flavor of a Mongolian folk song with its melody bold and heroic, free and well developed, fully expressing the true love between lovers. After the movie came out in 1953, the song became popular all over the country.

Lyrics:

Man:

The full moon is high in the sky,

Why is there no cloud around it?

I'm waiting for my beautiful girl,

Why have you not come yet?

Girl:

If the rains don't come,

Crabapple flowers cannot bloom.

As long as you wait patiently,

Your sweetheart will soon arrive.

蒙古草原上的敖包
An obo on Inner Mongolian grassland

宗巴朗松 ⑮ Zongba Langsong

扫码欣赏
Scan the code to appreciate

藏族民歌
A Tibetan folk song

二、民歌（10 首）

藏族有五百多万人，是我国少数民族中历史悠久、文化发达的民族之一。在漫长的历史发展过程中，藏族人民创造了丰富多彩的音乐文化。早在 12 世纪即出现了论述藏族音乐的专著，如萨班达智·贡格坚赞（1182—1251）的《论音乐》。藏传佛教的寺庙中至今保存和使用着藏族古老的图形乐谱——央移谱和用藏文字母书写的"切同来"乐谱，它们都是藏族音乐文化宝库中的珍贵遗产。

囊玛是藏族传统歌舞音乐，主要流行在拉萨市。因在布达拉宫内的囊玛康（即内室）演出而得名。因其历史悠久，被视为藏族的古典歌舞。

关于囊玛的来源，说法颇多。其一是说在 17 世纪时，拉达克国王带领该地区的格尔舞队到拉萨朝拜五世达赖喇嘛，在布达拉宫表演了歌舞，五世达赖喇嘛对他们的表演十分欣赏，遂命令在拉萨成立"格尔"歌舞队向拉达克人学习，囊玛就是在这一基础上逐渐发展起来的。另有学者根据囊玛中的许多歌词是六世达赖喇嘛仓央嘉措（1683—1706）的作品，认为囊玛为仓央嘉措所首创。还有学者从字义上剖析，认为囊玛的"囊"是"内"的意思，所以囊玛应为内向性歌舞，而这种内向性歌舞是公元 17 世纪时，藏王桑结嘉措邀集权贵至朋到囊玛康歌舞赋诗后逐渐形成的。

Selected Well-known Chinese Songs
II. Folk songs (Ten Pieces)

There are over five million Tibetans in China. The Tibetan people have created a colorful music culture in the course of their long history. As early as the 12th century, a number of monographs were written on music. *On Music* by Sakya Pandita Kunga Gyaltsen (1182–1251 AD) is one of such early works. Ancient Tibetan musical notations, such as the *yangyi* and the *qietonglai* notation written in the Tibetan alphabet are still used in Tibetan Buddhist monasteries. They are a valuable legacy of the Tibetan music culture.

Nangma is a kind of traditional Tibetan singing and dancing music popular in Lhasa. It got its name from the traditional performance held in *nangmakang* (the inner chamber) of the Potala Palace. Because of its long history, it is regarded as classical Tibetan singing and dancing music.

There are several versions about the origin of *nangma*. In the 17th century, to pay a tribute to the fifth Dalai Lama, the king of Ladakh led his gull dance troupe to the Potala Palace in Lhasa. The singing and dancing was very much appreciated by the fifth Dalai Lama, who then ordered to organise a gull singing and dancing troupe in Lhasa to learn from the troupe from Ladakh. It was from this gull troupe that *nangma* has gradually developed. Another version based on some scholars' belief is that *nangma* was initiated by Tsangyang Gyasto (1683–1706), the sixth Dalai Lama since many lyrics of *nangma* were his works. A number of other scholars' analyses are based on the etymology of the word *nangma*, the first syllable of which means "inner". Thus the term *nangma* must be a kind of introversive singing and dancing which is

二、民歌（10首）

八世达赖喇嘛（1758—1804）当政时期，西藏和尼泊尔发生军事冲突，起初藏军失利，清政府怀疑西藏贵族登者班觉通敌，将其押到北京审讯，后来发现是冤案，便释放了他，还赐其旅游各地名胜以示安抚。登者班觉喜爱音乐歌舞，在北京和去外地游历期间，广泛接触了汉族和其他兄弟民族的音乐歌舞，并将汉族乐器扬琴、笛子、二胡等带回西藏，把汉族音乐歌舞的因素融入西藏歌舞中，有人认为囊玛由此产生。

囊玛的音乐一般由引子、歌曲和舞曲三个部分构成。引子的曲调是固定的，由乐队演奏。歌曲部分的曲调为优美抒情的慢板，音乐典雅，节奏舒展，以唱为主，表演者偶尔也做小的舞蹈动作来配合演唱。舞蹈动作潇洒、悠然、大方；时而向左复而向右踏点转圈，不时拂袖转动手腕，做拖步施礼动作。歌曲部分的唱词比较广泛，其中以情歌居多，也有如"宝贝拿在手里，并不知道爱惜，一旦失落离去，后悔也来不及"等具有哲理性的诗句。舞曲部分欢快热情、活泼跳跃，表演者只舞不唱，有时在脚下垫一

related to Sangye Gyasto, the Tibetan King in the 17th century, who often invited important personages to the *nangmakang* to sing, dance and write poems.

Still another version is connected to the eighth Dalai Lama (1758–1804) during whose reign Tibet and Nepal were involved in a military conflict. At first, the Tibetan troops suffered a setback which made the Qing Regime suspect a Tibetan nobleman, Dengzhe Banjue, turning traitor. He was arrested and escorted to Beijing for trial. However, he was found innocent and set free. To placate him, the Qing Regime gifted him with a tour to many scenic spots in the country. Dengzhe Banjue loved singing and dancing music very much. During his visit to many places, he got extensive exposure to the singing and dancing music of Han and other nationalities. He not only brought back to Tibet such musical instruments as dulcimer, flute, and erhu, but also blended the essences of all this music into Tibetan singing and dancing music as well. Some people hold that *nangma* stemmed from this.

Nangma generally consists of three parts: the prelude, the song, and the dance music. The music of the prelude is fixed and performed by a band. Beautiful and lyrical, the elegant music of the song is a kind of adagio. Occasionally the singer will make a few small movements to accompany his/her singing. The movements are natural, unrestrained, relaxed and free. The singer whirls now to the left, now to the right, stomping and waving, making the movement of saluting by shuffling steps. Lyrics of the song cover many subjects, but most

块木板,脚在木板上踏出明快的声响,整个囊玛便在舞曲的高潮中结束。囊玛的音乐伴奏起初要求很严,必须由七种乐器组成,即笛子、六弦琴、扬琴、京胡、二胡、根卡、串铃,否则不能称为囊玛。到了十二世达赖时期(1856—1875),囊玛开始在民间盛行,民间一般只用横笛、扬琴、六弦琴三件乐器,甚至只用一件乐器也可以伴奏。

《宗巴朗松》是囊玛的代表作之一,它是一首情歌,据传为六世达赖喇嘛仓央嘉措所作。其旋律典雅优美、抒情委婉,和江南丝竹名曲《灯月交辉》有渊源关系,可能是由登者班觉从北京带到拉萨的丝竹乐曲演变而来的。

of them are love songs. Yet there are also philosophical lines such as "One never treasures any valuables in hand ,but when they are lost it is too late to regret". As to the third part of the dance music, which is of joy and ardor, lively and active, the performers will only dance without singing. Sometimes they put a piece of wood under their feet and stamp on it to produce a sharp sound with fast tempo. The whole performance of *nangma* will come to an end at the climax of the dance music.

Initially, there were strict requirements for music accompaniment. Seven music instruments were needed: flute, guitar, dulcimer, Beijing opera fiddle, *erhu*, *genka* and a ring of bells. Without these the performance could not be called *nangma*. It was not until the reign of the twelfth Dalai Lama (1856–1875) that *nangma* became popular among folks with only three instruments—flute, dulcimer, and guitar. Sometimes only one instrument was used for the performance.

"Zongba Langsong" is one of the representative works of *nangma*. According to the legend, it is a love song whose lyrics were written by Tsangyang Gyasto, the sixth Dailai Lama. Graceful, lyrical and euphemistic, the melody has the same source as that of the famous "Dengyue Jiaohui (Lanterns and Moonlight Are Vying for Brightness)" of silk-bamboo music of Southern Yangtze River. Probably "Zongba Langsong" was derived from part of this piece originally brought back by Dengzhe Banjue from Beijing to Lhasa.

二、民歌（10首）

歌词：

　　草原披上美丽的新装，

　　洁白的邦锦花遍地开。

　　只要鲜花开不败，

　　金色的蜜蜂儿会飞来。

Selected Well-known Chinese Songs
II. Folk songs (Ten Pieces)

Lyrics:

The grassland has a beautiful new dress to wear,

The Bangjin flowers are white everywhere.

As long as the beautiful flowers bloom,

Golden bees will always come here.

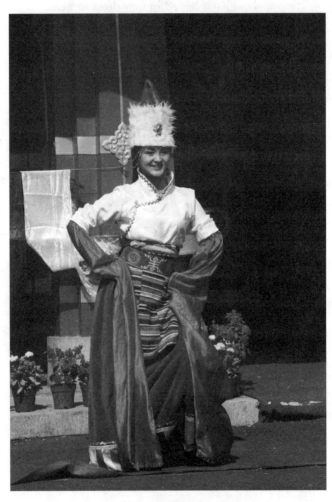

表演藏族歌舞的藏族女孩
A Tibetan girl performing Tibetan dance

中国名歌选萃
Selected Well-known Chinese Songs

20 世纪创作歌曲（15 首）

Songs Created in the 20th Century
(Fifteen Pieces)

教我如何不想她 ⑯ How Could I Not Miss Her

扫码欣赏
Scan the code to appreciate

刘半农词　赵元任曲
Lyrics by Liu Bannong, music by Zhao Yuanren

中国名歌选萃
三、20世纪创作的歌曲（15首）

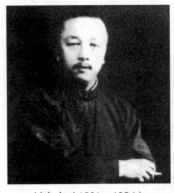

刘半农（1891—1934）
Liu Bannong (1891–1934)

《教我如何不想她》是我国最著名的艺术歌曲之一。其词是刘半农（1891—1934）于1920年在伦敦写的一首抒情白话诗，1926年赵元任（1892—1982）为其谱曲后，便在我国知识界广泛流传开来。

刘半农是语言学家、诗人、小说家、翻译家，而且还是"五四"新文化运动的先锋。他在语音学方面的成就，主要是对汉语四声的实验。他还创造了汉字中作为女性的第三人称代词的"她"字，并在此歌的歌词中首次运用。

赵元任是中国现代语言学和音乐学的先驱、作曲家，也是中国第一位用科学方法做方言和语音调查的学者。他在20世纪20年代和30年代曾亲自考察和研究过中国近60种方言，并创作有艺术歌曲、合唱歌曲和器乐曲等音乐作品。

《教我如何不想她》的歌词反映了20世纪初"五四"时期的青年在挣脱束缚、追求个性解放的潮流中，对执着、纯真爱情的热情讴歌和向往。这首歌的旋律优美、丰满，不但精确传递了歌词的精神，更提升了歌词意境，引人入胜地表现了情思萦绕的青年独自徘徊咏唱的情景。

赵元任（1892—1982）
Zhao Yuanren (1892–1982)

赵元任采用西洋作曲手法，但旋律则为中国风格，也不是根

Selected Well-known Chinese Songs
III. Songs Created in the 20th Century (Fifteen Pieces)

"How Could I Not Miss Her" is one of the most famous art songs in China. Its lyrics were written in 1920 by Liu Bannong (1891–1934) in London as a free verse poem in vernacular Chinese. The music for it was composed in 1926 by Zhao Yuanren (1892–1982). The song became popular among the intelligentsia in China.

Being a linguist, poet, novelist and translator, Liu Bannong was a vanguard of the New Culture Movement. Among his achievements are his experiments in phonetics for the four tones in the Chinese language. It was he who created the Chinese character "she"(她) as the singular third-person pronoun for the female and "she" was used in the lyrics of this song for first time.

Zhao Yuanren was the pioneer of modern Chinese linguistics and music composition, as well as the first scholar who conducted the survey of dialects and phonetics in a scientific way in China. He studied nearly 60 dialects in China in the 1920s and 1930s. As a composer, his musical works include art songs, choral songs, and some instrumental pieces.

The lyrics for "How Could I Not Miss Her" reflect the aspiration of true love among young people in the May Forth era in the 1920s when they were struggling to get rid of the feudal ethics and pursue personal freedom. With very beautiful and colorful melody, the song is about a young man haunted by his lovesickness while wandering and singing alone.

Zhao Yuanren adopted the Western way of composing music,

据民族传统曲调改编而成的。由于点题的乐句"教我如何不想她"采用了京剧西皮原板过门的音调加以变化，从而使歌曲的民族风格显得格外突出。四段歌词用分节变奏曲式谱写，前三段的末乐句相同，第四段的末乐句保持了原来的节奏型，因情绪表现需要，音调上有所变化。每段间用同一乐句作间奏，加强了全曲的统一性。赵元任在这首歌里，以十分娴熟的技巧运用了西洋的转调手法，这在那个年代的中国作品中，是颇为大胆、新颖的创作手法。

关于刘半农的这首歌词还有一则有趣的传说。1930年前后，赵元任夫人杨步伟在北京女子文理学院任教，她的那些女学生们都非常爱唱这首歌。后来刘半农奉命接管该学院，穿了一件中式的蓝棉布袍子来上班，女生们便纷纷议论："听说刘半农是一个很风雅的文人，怎么会是一个土老头？"杨步伟听到后告诉她们："他就是你们天天在唱的《教我如何不想她》中的那个'他'呀！"女生们说："这个人不像。"还有的问："这首歌不是你家赵先生写的吗？"杨步伟说："曲是赵先生所谱，但歌词是他写的呀。"刘半农知道此事后，写了一首诗："教我如何不想他，请来共饮一杯茶。原来如此一老叟，教我如何再想他。"

Selected Well-known Chinese Songs
III. Songs Created in the 20th Century (Fifteen Pieces)

but the melody of the song has a Chinese flavor, yet he did not adapt the melody from tunes of traditional Chinese folk songs. However, he adopted with some changes the tune of the short interlude of Xipi melody of Peking opera. The four stanzas are written in variations of a strophic form with the first three sharing the same ending phrase. The fourth one keeps the original rhythmic pattern but makes some necessary changes in tune because of an emotional expression need. Between each stanza, the same phrase is used as the interlude to enhance the consistency of the music. Zhao Yuanren skillfully uses the Western way of modulation in the song which was indeed an innovation in music works in China at that time.

There is an amusing anecdote regarding the lyrics by Liu Bannong. It is said that Yang Buwei, wife of Zhao Yuanren, was teaching at Beijing Women's Liberal Arts College around 1930. Her students liked the song very much. Later on Liu Bannong became director of the college. Clad in a Chinese blue gown lined with cotton, he went to work. The students started gossiping, "It is said that Liu Bannong is an elegant man of letters. How come he turns out such an uncouth old man?" Yang Buwei told them, "He is the Him of the song 'How Could I Not Miss Her[①]' that you sing every day." "He does not seem to be the Him," some of the students said. Some asked, "Isn't it written by your husband, Mr. Zhao?" Yang explained to them, "The music of the song is done by Mr. Zhao while the lyrics are written by Him." When Liu Bannong heard of this, he was amused and wrote the

① There is no difference between "him" and "her" in Chinese pronunciation.

三、20世纪创作的歌曲（15首）

歌词：

天上飘着些微云，
地上吹着些微风。
啊！
微风吹动了我头发，
教我如何不想她？
月光恋爱着海洋，
海洋恋爱着月光。
啊！
这般蜜也似的银夜，
教我如何不想她？

水面落花慢慢流，
水底鱼儿慢慢游。
啊！
燕子你说些什么话？
教我如何不想她？

枯树在冷风里摇，
野火在暮色中烧。
啊！
西天还有些儿残霞，
教我如何不想她？

Selected Well-known Chinese Songs

III. Songs Created in the 20th Century (Fifteen Pieces)

doggerel: "How could I not miss him? Please come and have a cup of tea. There came such an old man. How could I miss him once again?"

Lyrics:

Tiny clouds drift in the sky,

A breeze blows on the ground.

Ah!

The breeze rustles my hair,

How could I not miss her?

The moonlight loves the sea,

The sea loves the moonlight.

Ah!

This sweet silvery night,

How could I not miss her?

Fallen flowers slowly float on the surface of the water,

Small fish slowly swim in the water,

Ah!

My swallows, what are you saying?

How could I not miss her?

The withered tree sways in the chilled wind,

The prairie fire burns at twilight.

Ah!

Remnants of sunset's orange clouds are still in the west.

Tell me, how could I not miss her?

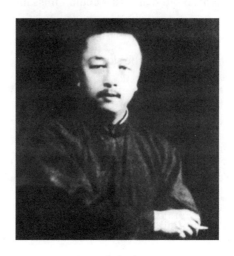

刘半农
Liu Bannong

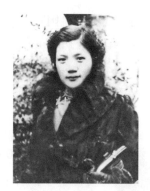

渔 光 曲 ⑰ A Fishermen's Song

扫码欣赏
Scan the code to appreciate

安娥词　任光曲
Lyrics by An E, music by Ren Guang

中国名歌选萃
三、20世纪创作的歌曲（15首）

《渔光曲》为作曲家任光的代表作，作于1934年，是同名电影的主题歌。影片以凄婉的笔调描写了当时渔民的苦难生活。1935年，影片《渔光曲》在莫斯科国际电影展览会上被授予"荣誉奖"，是我国第一部获国际奖的故事片。贯穿整部影片的主题歌《渔光曲》，旋律委婉动人，在影片放映后，成为流行全国的歌曲。

任光（1900—1941）
Ren Guang (1900–1941)

任光（1900—1941），笔名前发，生于浙江省嵊州市。任光自幼喜爱民间音乐，会拉琴，爱看绍剧，爱听当地的民间说唱莲花落。1919年赴法勤工俭学，入里昂大学音乐系学习，并在一家钢琴厂当学徒。1924年毕业后，曾任越南亚佛音乐钢琴制造厂经理。1928年回国后，在上海百代唱片公司任音乐部主任，从事歌曲创作并为电影、戏剧配乐。1937年再度赴法，入巴黎音乐师范学校进修。1938年回国后，在长沙、贵阳等地从事抗日宣传活动。1940年，任光跟随叶挺将军由重庆赴皖南参加新四军。1941年在皖南事变中不幸牺牲，年仅40岁。

《渔光曲》词作者安娥（1905—1976），原名张式沅，河北省获鹿县人，著名诗人、剧作家、记者和社会活动家。1925年肄业于北京国立美专，1927年赴莫斯科中山大学学习。1929年回国后开始诗歌创作。先后参加"中国左翼作家联盟""中国左翼戏剧家联盟"。1933年至1937年，安娥在上海百代唱片公司任歌曲部主任，与任光合作创作了大量旋律悦耳、意境优美的歌曲。

Selected Well-known Chinese Songs
III. Songs Created in the 20th Century (Fifteen Pieces)

Written in 1934, "A Fishermen's Song" is the work of the composer, Ren Guang. It is the theme song of the movie by the same name, dealing with the miserable life of the fishermen at the time. It won the Honorary Award at the Moscow International Film Exhibition in 1935. It was the first Chinese feature film which got international recognition. With its touching music throughout the movie, "A Fishermen's Song" gained its popularity after the movie was released.

Born in Shengzhou County, Zhejiang Province, Ren Guang (1900–1941), liked folk music. Since his childhood he was able to play traditional musical instruments and was a fan of Shaoxing opera and *lianhualao*, a kind of local folk ballad singing. He went to France in 1919 to learn music at the Music School of Lyon University under a work-study program and also worked as an apprentice at a piano factory. After he graduated in 1924, he became the manager of Yafuo Piano Factory in Vietnam. Coming back to China in 1928, he was appointed the director of the Music Department of Baidai, a French phonograph company. In the meantime, he started composing songs and music for movies and plays. He went to France again in 1937 to further his study at Ecole Normale de Musique de Paris. He was killed in 1941 in the Southern Anhui during a war at age 40.

Born in Huailu County, Hebei Province, An E (1905–1976), the librettist of the song, was a well-known poet, dramatist, journalist and social activist in China. In 1925 she studied at the Beijing National Academy of Fine Arts and furthered her studies at Moscow Sun Yat-sen University in 1927. She started writing poetry after returning to China in 1929 and became a member of League of Left-wing Writers and that of the Chinese Left-wing Dramatists Union. She was

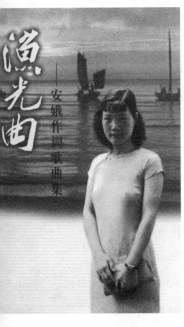

抗日战争时期,她辗转武汉、重庆、桂林、昆明等地,抗日战争胜利后回到上海。新中国成立后在北京人民艺术剧院、中央实验话剧院、中国戏剧家协会任创作员,有《安娥文集》存世。

任光为了谱写《渔光曲》,曾深入海边,体验渔民的生活与劳动。《渔光曲》用质朴真实的歌词和委婉惆怅的旋律,鲜明地描绘了20世纪30年代中国渔村破产的凄凉景象。音乐中饱含了渔民的血泪,感情真挚,展示了当时渔民的悲惨生活遭遇,抒发了他们心中不可遏制的怨恨情绪。歌曲采用单三部曲式,各段音调虽有变化,但由于要刻画出渔船在海上颠簸起伏的形象,采用了统一的节奏型和相同的引子及间奏,使音乐浑然一体。

曲调虽然采用了五声音阶中的宫调式,但色彩并不明朗,而是表露出一丝哀愁和压抑。各个乐段都运用了具有民族风格的"起承转合"四句式,使这首歌具有很强的民族风格。

歌词:

云儿飘在海空,
鱼儿藏在水中。
早晨太阳里晒渔网,

Selected Well-known Chinese Songs
III. Songs Created in the 20th Century (Fifteen Pieces)

the director of the Songs Department of Baidai from 1933 to 1937. Working with Ren Guang, she wrote a large number of melodiously beautiful songs. During the War Against Japanese Invasion, she roved around in many different cities such as Wuhan, Chongqing, Guilin and Kunming. It was not until the victory of the War that she returned to Shanghai. After the founding of the People's Republic of China, she became a resident playwright at Beijing People's Art Theatre, Central Experimental Drama Theater and Chinese Dramatists Association.

In order to compose "A Fishermen's Song", Ren Guang lived for a while near the sea to experience the fishermen's way of life. As a result, "A Fishermen's Song" clearly depicts the mournful scene of a fishing village in China in the 1930s through its simple words and melancholy melody. The song uses the ternary form. Although there are some changes in tune of each stanza, the same rhythmic pattern, the same prelude and the same interlude are kept to integrate the music, evoking the fishing boats being tossed up and down by the waves.

Though the *gong* mode of the pentatonic scale is used, it is not displayed to its fullest so as to show a trace of sadness. Every stanza of the song has the four-sentences form of the four functional steps of opening, development, change, and conclusion of classical Chinese composition, so the song is therefore given a strong national style.

Lyrics:

Clouds are floating in the sky above the sea,
Fish are hidden in the water.
We dried the nets in the morning sun,

迎面吹过来大海风。
潮水升，浪花涌，
渔船儿飘飘各西东。
轻撒网，紧拉绳，
烟雾里辛苦等鱼踪。

鱼儿难捕船租重，
捕鱼人儿世世穷。
爷爷留下的破渔网，
小心再靠它过一冬。

东方现出微明，
星儿藏入天空。
早晨渔船儿返回程，
迎面吹过来送潮风。

天已明，力已尽，
眼望着渔村路万重。
腰已酸，手也肿，
捕得了鱼儿腹内空。

鱼儿捕得不满筐，
又是东方太阳红。
爷爷留下的破渔网，
小心还靠它过一冬。

Selected Well-known Chinese Songs
III. Songs Created in the 20th Century (Fifteen Pieces)

When sea breezes were blowing in our faces.

Tides rising, sprays jumping,

Fishing boats are going in all directions.

Cast the net light, hold the ropes tight,

We are waiting for traces of fish in the mist.

Hard to catch fish yet dear to rent a boat,

Fishermen are always poor.

Carefully we use the broken nets grandpa left,

And expect it to last for another winter.

Day breaks a little in the east,

Stars are hidden in the sky.

Boats are returning home in the morning,

Winds of the tide blow in our faces.

The day is fully bright and we are exhausted,

Our village seems a hundred miles away.

Waists are sour, hands swollen,

We got the fish but we still are very hungry.

Our baskets are not yet full with fish,

And again the sun is already high in the east.

Carefully we use the broken nets grandpa left,

And expect that it would last until this winter.

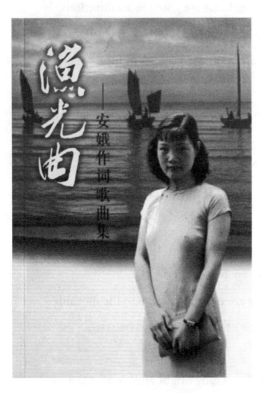

安娥作词歌曲集封面
Album cover of An E's lyrics

义勇军进行曲 ⑱ March of the Volunteers

扫码欣赏
Scan the code to appreciate

田汉词　聂耳曲
Lyrics by Tian Han, music by Nie Er

中国名歌选萃

三、20世纪创作的歌曲（15首）

《义勇军进行曲》是诗人田汉和作曲家聂耳于1935年为影片《风云儿女》所作的主题歌。这部影片描写了20世纪30年代初期，诗人辛白华为拯救危亡中的祖国，投笔从戎，奔赴抗日前线，英勇杀敌的故事。此歌作为主人公辛白华的长诗《万里长城》的最后一节，在影片中首尾两次出现，给观众留下了极为深刻的印象，影片放映后此歌很快流行全国，成为最著名的抗战歌曲。

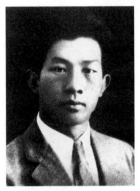

聂耳（1912—1935）
Nie Er (1912–1935)

聂耳（1912—1935），原名聂守信，云南玉溪人，生于昆明。聂耳自幼喜爱音乐，曾在家乡学习中国传统音乐。1932年他在上海联华影业公司工作，并组织"中国新兴音乐研究会"，自修了和声学与作曲法。1933年开始为电影、戏剧作曲，其后在不到两年的时间里，创作了37首歌曲，深刻地反映了当时劳动人民的思想感情，准确地塑造了工人、歌女、报童等劳动群众的音乐形象。在抗日救亡运动中，聂耳的这些歌曲产生了广泛而深远的影响，代表作有《义勇军进行曲》《大路歌》《码头工人》《新女性》《毕业歌》《飞花歌》《铁蹄下的歌女》《卖报歌》《梅娘曲》等。

田汉（1898—1968），湖南长沙人，诗人、剧作家、文艺批评家和社会活动家。田汉早年留学日本，19世纪20年代开始从事戏剧活动，写过多部著名话剧，成功地改编过一些传统戏曲。田汉与聂耳、

田汉（1898—1968）
Tian Han (1898–1968)

Selected Well-known Chinese Songs
III. Songs Created in the 20th Century (Fifteen Pieces)

"March of the Volunteers" is the theme song of the feature film *Youngsters in War-ridden Times*. The lyrics were written in 1935 by Tian Han, and the music was composed by Nie Er. The film is a story set at the beginning of the 1930s about a poet Xin Baihua, who joins the army to go to the frontier to slay enemies. In the film Xin Baihua writes a long verse called "the Great Wall", the last part of which is the theme song sung twice in the film, once at the beginning and then at the end. The movie audience was much moved. It became the most famous patriotic song nationwide after the film debuted.

Nie Er (1912–1935), originally named Nie Shouxin, was born in Kunming, Yunnan Province. Since his early childhood, he loved and learned traditional Chinese music. In 1932, he worked with Shanghai Lianhua Film Studio and organised the Research Workshop for Developing New Chinese Music. Having taught himself harmonics and composition, he started to compose music for films and plays in 1933. In less than two years he wrote 37 songs to reflect the contemporary condition of the working-class people. His songs such as "March of the Volunteers", "Song of Broad Road", "Dockers", "New Women", "A Song Sung at Graduation", "Flying Flowers", "Nightclub Girl Singers under the Iron Heel", "Song of the Newsboy", and "Song of Mei Niang" are among his masterpieces.

Tian Han (1898–1968), born in Changsha, Hunan Province, was a poet, dramatist, literary critic, and social activist. In his early years, he studied in Japan. In the 1920s, he became interested in theatre and wrote many famous modern dramas, successfully rewrote some traditional operas, and wrote numerous songs in cooperation with the

冼星海、张曙等合作创作了大量歌曲，其中的《毕业歌》《义勇军进行曲》等都曾广泛流传。

1934年，"电通"公司在上海成立，请田汉写电影剧本。那年冬天，田汉将剧本的初稿交给公司，第二年2月，田汉被捕入狱，这首歌的歌词，是他在监狱里时写在一张包香烟的锡纸衬底上，写好之后托人带出监狱的。当时，聂耳正准备东渡日本，得知影片有首主题歌要写，主动向孙师毅、许辛之等要求为之谱曲。聂耳在出国前完成了初稿，全曲是他在日本写好之后寄回国内的，它是聂耳最后、也是最杰出的作品。曲谱寄回上海之后，由贺绿汀请当时在上海百代唱片公司担任乐队指挥的俄罗斯作曲家阿龙·阿甫夏洛莫夫配器，不久就被使用在影片《风云儿女》中。

《义勇军进行曲》的歌词淋漓尽致地表现了中国人民抵御外敌、决死一战的坚强意志，堪称中国现代诗歌的名作。从形式上看，它是一首散文式的自由体新诗，句子有长有短，参差不齐，最短的只有2个音节，最长的则有13个音节。

聂耳创造性地把这首诗谱写成一个由前奏和6个乐句构成的自由体乐段，前奏和第六个乐句的长度均为6小节，首尾呼应，结构平衡。中间部分吸收中国传统音乐中"金橄榄"（1，3，5，7，5，3，1）的结构形式，第一乐句到第五乐句的长度分别为3小节、5小节、5小节、7小节和5小节，具有非常鲜明的民族特点。这首歌以号角式音调作为旋律发展的基础，曲调昂扬、振奋。全曲在军号声中开始，引出急切呐喊："起来！不愿做奴隶的人们！"，当唱道"中华民族到了最危险的时候"这句歌词时，作曲家在乐句中间用了突然的休止，造成紧迫感，使"最危险的时候"得到

Selected Well-known Chinese Songs
III. Songs Created in the 20th Century (Fifteen Pieces)

composers Nie Er, Xian Xinghai, and Zhang Shu.

In 1934 Diantong Film Studio asked Tian Han to write a movie script. Shortly after he delivered the first draft he was arrested and jailed. The lyrics for "March of the Volunteers" were written in jail on the inside wrapper of a package of cigarettes and smuggled out of prison. At that time, Nie Er was going to Japan. He finished the first draft of the music before he left. Then he polished the music and mailed it to China from Japan. After Nie Er's friend Mr. He Lvting received the notation, he asked the Russian composer, Aaron Avshalomov living in Shanghai, to orchestrate the music, which then was used in the film *Youngsters in War-ridden Times*.

"March of the Volunteers" is considered a masterpiece of modern Chinese poetry. It endeavours to express the strong will of the Chinese people to resist and fight against foreign invaders. In terms of its form, the poem is written in free verse, characteristic of the prose-like new poetry. In this poem, the shortest sentence has only two characters while the longest one, thirteen.

Nie Er composed the piece in free verse style consisting of a prelude, six phrases and a coda. The prelude and the sixth phrase are of the same length, making the beginning of the period echo with the end of it, resulting in a symmetrically balance structure. The so-called "golden olive" structure (1 , 3 , 5 , 7 , 5 , 3 , 1) in traditional Chinese music makes the lengths of the phrases from the first to the fifth to be 3 bars, 5 bars , 5 bars, 7 bars and 5 bars respectively, showing a very distinctive national characteristic. The melody is developed on the base of the do-mi-sol which are three tones of major triad. The music

强调。在"每个人被迫着发出最后的吼声"之后,"起来!"重复三次,音调层层向上,终于再现了号角的音调,激励着无数勇士冒着敌人的炮火前进。结尾时再三强调"前进"二字,表现了中国人民百折不挠、勇往直前的战斗步伐。

因为《义勇军进行曲》在中国人民争取自由解放的斗争中起过巨大的鼓舞作用,1949年9月27日,中国人民政治协商会议第一次全体会议通过决议,在中华人民共和国国歌正式制定前,以《义勇军进行曲》为代国歌。1982年12月4日,第五届全国人民代表大会第五次会议决议将其定为中华人民共和国国歌。

歌词:

起来!
不愿做奴隶的人们!
把我们的血肉,
筑成我们新的长城!
中华民族到了最危险的时候,
每个人被迫着发出最后的吼声!
起来!起来!起来!
我们万众一心,
冒着敌人的炮火前进,
冒着敌人的炮火前进!前进!前进!进!!

Selected Well-known Chinese Songs

III. Songs Created in the 20th Century (Fifteen Pieces)

is soaring and inspiring. It begins with the sounds of a bugle bringing forth the urgent cry: "Arise, people who refuse to be slaves." When the sentence "China is in danger" is sung, the composer uses an abrupt stop in the middle of the phrase to build a sense of urgency, placing the stress on "in danger". After the phrase "All need to give out a roar", "Arise!" is repeated three times in a crescendo, and the sounds of the bugle are heard again, urging people to march toward the enemies' gunfire. The ending "March on" is repeated to show the marching steps of Chinese people who are roused to bravely march into the battle.

In Sept. 27, 1949, "March of the Volunteers" was selected as the provisional national anthem of the People's Republic of China. On Dec. 4th, 1982, the fifth session of the fifth National People's Congress voted the song to become the official national anthem of the People's Republic of China.

Lyrics:

 Arise, people who refuse to be slaves,
 Let our flesh and blood forge our new Great Wall!
 As China has arrived at the direst moment!
 All need to expel his final roar!
 Arise! Arise! Arise!
 A million hearts beating as one,
 Braving the enemy's fire, March on,
 Braving the enemy's fire, March on!
 March on! March on and on!

聂耳与田汉 1933 年摄于上海
A picture of Nie Er and Tian Han taken in Shanghai in 1933

二月里来 ⑲ In February

扫码欣赏
Scan the code to appreciate

塞克词　冼星海曲
Lyrics by Saike, music by Xian Xinghai

三、20世纪创作的歌曲（15首）

《二月里来》是《生产大合唱》中的一首歌，1939年3月作于延安，由塞克作词、冼星海作曲。

冼星海（1905—1945）
Xian Xinghai (1905-1945)

冼星海（1905—1945）是我国著名作曲家，原籍广东番禺，生于澳门。1918年入岭南大学附中学小提琴，1926年在北京国立艺术专门学校音乐系选修小提琴，1928年入上海国立音乐学院学小提琴和钢琴。1929年赴法学习小提琴及作曲，1931年入巴黎音乐学院。1935年回国，先后在上海百代唱片公司和新华影业公司从事音乐创作。后投身于抗日救亡歌咏运动，在1935年至1938年之间，创作了《救国军歌》《在太行山上》《到敌人后方去》等数百首优秀歌曲。1938年应鲁迅艺术学院之邀赴延安，任音乐系教授、系主任。在延安创作了《黄河大合唱》《生产大合唱》等大型声乐作品。1940年赴苏联，在那里创作了数首交响乐及大量其他管弦乐作品，1945年病逝于莫斯科。

塞克（1906—1988），原名陈秉钧，河北霸县人，诗人、剧作家，20世纪30年代中期取"塞克"为笔名，为布尔塞维克之缩略，并沿用终生。1927年，塞克在上海参加田汉领导的"南国社"，开始话剧表演生涯，同时开始写作歌词，写了《救国军歌》《心头恨》《抗日先锋队》等歌词。1938年到延安鲁迅艺术学院任教，创作了《生产大合唱》等作品。抗战结束后，他先后担任热河省文联主任、东北鲁迅文艺学院院长和东北人民艺术剧院院长。1953年后任中央实验歌剧院顾问。

Selected Well-known Chinese Songs
III. Songs Created in the 20th Century (Fifteen Pieces)

"In February" is part of "Production Cantata", a song written by Saike and composed by Xian Xinghai in Yan'an, in March 1939.

China's famous composer Xian Xinghai (1905–1945) was born in Macao. He started to study the violin in 1918, continued his studies at the Music Department of Beijing National Art School in 1926, and took up piano in Shanghai Conservatory of Music in 1928. In 1929, he went to France to learn composition and the violin, and from 1931 to 1935 he studied at Paris Conservatory of Music. In 1935, he worked at Baidai and Xinhua Film Studio. From 1935 to 1938, he wrote many patriotic tunes, including "An Army Song for Saving the Country", "In Taihang Mountains", and "Taking the Enemy in an Ambush". In 1938, he became dean and professor of Luxun Art Academy and composed large-scale vocal music pieces such as "The Yellow River Cantata" and "Production Cantata". In 1940, he wrote symphonies and a large number of other orchestral music while in the Soviet Union. He passed away in Moscow in 1945.

Chen Binjun, known professionally as Saike (1906–1988), the famous poet and dramatist, was born in Baxian County, Hebei Province. Joining the Nanguo Theatre Company led by Tian Han, he started his career as a performer of modern dramas in 1927, and wrote the lyrics for such songs as "An Army Song for Saving the Country", "Ranking Hatred" and "Vanguards Against Japanese Invasion". He began to teach at Luxun Art Academy from 1938 where he wrote the lyrics for "Production Cantata". He held a number of offices, such as director of Literary Federation of Rehe Province, president of Northeast Luxun

中国名歌选萃

三、20世纪创作的歌曲（15首）

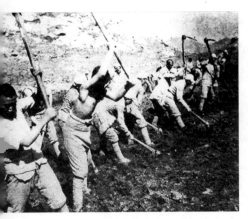

《生产大合唱》是冼星海创作的四部大合唱中的第一部，实际上是有人物、有布景、有简单情节的大型声乐表演，风格清新而明朗。全曲分"春耕""播种与参战""秋收""丰收"四场。《二月里来》是在风和日丽的播种场面中，以非常恬静、安适的情绪唱出的一首抒发抗日战争时期人民群众为支援前线而努力生产的抒情歌曲。

《二月里来》的旋律柔婉流畅，感情细腻真挚，具有恬静的江南风味和浓郁的民歌风格。多处装饰音的运用，更增添了曲调秀美的抒情色彩。这首歌在延安首演后受到观众一致好评，后多作为独唱歌曲演唱，是我国许多歌唱家的保留曲目。

起承转合是我国古代诗歌，也是我国民歌中常用的一种结构形式。《二月里来》是典型的起承转合四句体乐段结构，虽然结构短小简单，但每个乐句的节奏安排均不相同，既统一又有变化。

歌词每段的前两句是起句和承句，结尾都落在徵音（sol）上，以共同的落音构成呼应；第三句落在角音（mi）上，连续的两个切分节奏也同前面两个乐句形成了鲜明的对比，起到了转折的作用。第四句再现了第一、二乐句的音调和第三乐句的切分节奏，

Selected Well-known Chinese Songs
III. Songs Created in the 20th Century (Fifteen Pieces)

Art School, and director of Northeast People's Art Theatre. In 1953, he was appointed consultant of the Central Experimental Opera House.

As the first one of the four cantatas composed by Xian Xinghai, "Production Cantata" is actually a grand vocal music performance with a rather simple plot. It has four acts: Ploughing in Spring, Seeding and Going to the Front, Cropping in Autumn and Sumptuous Harvest. "In February", which is part of the cantata, is a lyrical song, peaceful and calm, attempting to express the emotions of people working hard to sow seeds on a sunny day to support the army on the frontline during the War Against Japanese Invasion.

Smooth and gentle in its melody, exquisite and sincere in its expression, "In February" carries flavours of the tranquil Jiangnan region (areas south of the Yangtze River) and that of the elaborate folk songs. Made more lyrical due to the use of ornamentation, it debuted successfully in Yan'an and have been kept in the repertoires of many Chinese solo singers ever since.

"In February" is arranged in the period structure of four sentences, according to ancient versification and folk lyric tradition. Short and simple in structure, the rhythm arrangements of the periods vary to make them different from each other yet consistent with each other.

Serving as introduction, the first two phrases both end at the same *zhi* note (sol), echoing each other. Ending at the *jue* note (mi) along with two successive syncopated rhythms, the third transitional phrase sharply contrasts with the first two. Encompassing the melodic

中国名歌选萃

三、20世纪创作的歌曲（15首）

最后落在宫音上，完满地结束全曲，为典型的合句。

歌词：

二月里来呀好春光，
家家户户种田忙，
指望着今年的收成好，
多捐些五谷充军粮。

二月里来呀好春光，
家家户户种田忙，
种瓜的得瓜呀种豆的得豆，
谁种下仇恨他自己遭殃。

加紧生产哟加紧生产，
努力苦干哟努力苦干！
我们能熬过这最苦的现阶段，
反攻的胜利就在眼前！

加紧生产哟加紧生产，
努力苦干哟努力苦干！
年老的年少的在后方，
多出点劳力也是抗战！

elements of the first and the second phrases and the syncopation in the third, the fourth phrase falls on the *gong* note (do) to bring the whole song to a pleasing end.

Lyrics:

In February, spring is coming,

Every household is busy farming,

Looking forward to a good harvest this year,

We will donate more grains to our army.

In February, spring is coming,

Every household is busy farming,

Sowing seeds of melons will harvest melons,

He who sows the seeds of hatred will crop disaster.

Try to produce more,

And work harder!

We'll go through the hardest time now,

Our victory is at hand!

Try to produce more,

And work harder! Old and young in rural areas!

When you take part in farm work,

You are contributing to the Resistance War!

抗战时期八路军战士开荒
The soldiers of the 8th Army open up wasteland during the War Against Japanese Invasion

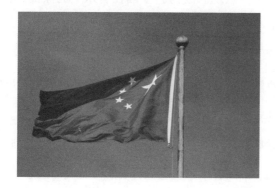

歌唱祖国 ⑳ Ode to the Motherland

扫码欣赏
Scan the code to appreciate

王 莘词、曲
Lyrics and music by Wang Xin

中国名歌选萃
三、20世纪创作的歌曲（15首）

歌词鲜明生动、旋律明快雄壮的《歌唱祖国》是我国著名的爱国歌曲，这首歌现已成为新中国在音乐上的象征，也是我国在各种重大庆祝活动中经常演唱和演奏的音乐作品。

歌曲的作者王莘（1918—2007）是江苏无锡人，自幼酷爱音乐，曾就学于延安鲁迅艺术学院音乐系，是冼星海的学生。中华人民共和国成立后在天津工作，历任天津市音乐工作团团长、天津歌舞剧院院长、中国音乐家协会天津分会主席等职务。

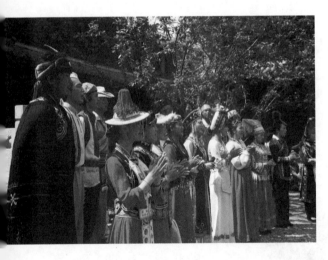

王莘青年时代投身革命，对新中国的诞生有火一般的激情。1950年9月15日，他到北京去购买乐器，返程时路过天安门广场，下车游览。天安门广场上的节日气氛令王莘十分激动，鲜红的国旗在傍晚的霞光中飘扬，更激发了他的灵感。一曲雄壮有力、气势宏伟的旋律，伴着凝练的歌词从他心底涌出，化作了这首热情奔放的唱给祖国的颂歌。歌曲是他在返回天津的火车上创作的，刻画了中国这个业已站立起来的东方巨人的伟大形象，记录了中国人民豪迈的前进步伐，讴歌了中华各民族儿女对祖国美好未来的憧憬。

Selected Well-known Chinese Songs
III. Songs Created in the 20th Century (Fifteen Pieces)

As the musical symbol of a new China with its clear-cut words, strong and bright music, "Ode to the Motherland" is one of the most famous Chinese patriotic songs frequently sung or played in many great celebrations in China.

Born in Wuxi, Jiangsu Province, the writer of the song Wang Xin (1918–2007) loved music from an early age. He studied under Xian Xinghai at Luxun Art Academy in Yan'an. After the founding of the People's Republic of China, he worked in Tianjin, as director of the Tianjin Troupe of Music Workers, president of Tianjin Song and Dance Theatre, and chairman of Tianjin Branch of China's Musicians Association.

Devoted himself to revolution since his adolescent years, Wang Xin has burning passions for the birth of a new China. On his way back to Tianjin after buying some musical instruments in Beijing on Sept. 15, 1950, he took off a bus to have a look at Tian'anmen Square for sightseeing. The holiday atmosphere of Tian'anmen Square excited him a great deal and the red national flag fluttering under the sunset glow inspired his inspiration. A powerful and magnificent melody together with compact and condensed words poured out from his mind as an outburst of enthusiasm to turn it into this ode sung to our motherland. Writing the song on the train back to Tianjin, he depicted the great image of China who has stood up as an oriental giant, recorded the marching steps of Chinese people bravely moving forward and sang praise for the beautiful vision that the sons and daughters of Chinese people cherish for the future of their motherland.

中国名歌选萃

三、20世纪创作的歌曲（15首）

《歌唱祖国》既继承了中国革命歌曲的传统，又具有新时代的新风格。歌曲旋律气势豪迈而充满深情，音调连贯统一又富有变化。全曲由长度相等的两个乐段组成，第一乐段只有一段歌词，是歌曲主题的体现，第二乐段有三段歌词，表现同一主题的不同侧面，二者在节奏、结构和音调等各方面都形成强烈的对比，是一首具有深刻思想性，又具有高度艺术性的作品。

1951年9月，中央人民广播电台播放了由中央乐团演唱的大合唱《歌唱祖国》，很快这首歌便流传开来。1980年5月，中央人民广播电台更将这首歌作为全国联播节目的开始曲。

歌词：

五星红旗迎风飘扬，
胜利歌声多么响亮；
歌唱我们亲爱的祖国，
从今走向繁荣富强。

越过高山，越过平原，
跨过奔腾的黄河长江；
宽广美丽的土地，
是我们亲爱的家乡。

Selected Well-known Chinese Songs
III. Songs Created in the 20th Century (Fifteen Pieces)

With momentum and affection in its melody, "Ode to the Motherland" not only preserves the traditions of Chinese revolutionary songs, but shows a new style as well. Its tone is coherent yet varied. The first period has the same length as the second. Each stanza of the words in the second period is different from each other to present various aspects of the same theme yet the words of the first period keep unchanged to give expression to the theme of the song. Thus in sharp contrast in rhythm, structure and tone, the first and the second periods make a song of profound ideology and highly artistic significance.

China National Radio broadcasted the song "Ode to the Motherland" performed by Chorus of China Central Orchestra in September, 1951. Soon the song got well known at home and abroad. In May, 1980, China National Radio adopted the song as the theme melody of the national broadcast program.

Lyrics:

The red flag with five stars flutters in the wind,
The victorious song is loud and happy.
We sing of our dear motherland with love,
Who is marching towards prosperity.

Our songs float over mountains and plains,
The Yellow River and the Yangtze River;
All of them are part of our beautiful country,
The heroic people stand strong as steel.

三、20世纪创作的歌曲（15首）

英雄的人民站起来了！
我们团结友爱坚强如钢。

我们勤劳，我们勇敢，
独立自由是我们的理想；
我们战胜了多少苦难，
才得到今天的解放！
我们爱和平，我们爱家乡，
谁敢侵犯我们就叫他灭亡！

东方太阳，正在升起，
人民共和国正在成长；
我们领袖毛泽东，
指引着前进的方向。
我们的生活天天向上，
我们的前途万丈光芒。

Selected Well-known Chinese Songs
III. Songs Created in the 20th Century (Fifteen Pieces)

We, diligent and brave, long for freedom!

We've won through dire suffering.

We love peace and we love our dear country,

We are ready to defend her from aggression.

Our people's republic is prospering,

Like the sun rising in the east;

The party headed by Mao Zedong,

Leads us from victory to victory.

Forwards to the brilliant future,

As well as a better and better life.

五星红旗迎风飘扬
National flag of China

我 的 祖 国 ㉑ My Motherland

扫码欣赏
Scan the code to appreciate

乔羽词　刘炽曲
Lyrics by Qiao Yu, music by Liu Chi

三、20世纪创作的歌曲（15首）

由乔羽作词、刘炽作曲的著名爱国主义歌曲《我的祖国》是电影《上甘岭》的插曲，作于1956年。

影片《上甘岭》反映的是在抗美援朝战争最激烈的一次战役中，中国人民志愿军在极其艰苦的条件下奋勇杀敌的英雄事迹。这首歌唱出了志愿军战士对祖国、对家乡的无限热爱之情和英雄主义的气概。歌词真挚朴实、亲切生动，词中的"大河""白帆""姑娘""美酒"等构成一幅幅美丽而感人的画面，是祖国的写照，唤起人们强烈的共鸣。曲调的前半部是抒情的女高音领唱，汹涌而来的思乡之情洋溢在委婉动听的旋律之中。三段歌是三幅引人入胜的美丽图画，仿佛让人看见了祖国江河上帆影飘移、田野上稻浪飘香的旖旎景色。曲调的后半部是副歌，混声合唱与前面的领唱形成鲜明对比，仿佛山洪喷涌而一泻千里，尽情地抒发战士们的激情。全曲将抒情歌曲与颂歌两种不同的体裁形式合二为一，富有创造性。歌唱家郭兰英的出色领唱，更增添了歌曲的艺术感染力。半个多世纪以来，这首歌作为一首歌唱祖国的佳作在我国广泛流传。

乔羽（1927— ）
Qiao Yu (1927-)

乔羽（1927— ），山东济宁人，著名词作家，代表作有电影文学剧本《刘三姐》《红孩子》，歌词《我的祖国》《牡丹之歌》《人说山西好风光》《让我们荡起双桨》等在中国家喻户晓的作品。

刘炽（1921—1998），陕西西安人，著名作曲家。他自幼喜爱音乐，曾随民

The lyrics for "My Motherland", the interlude to the movie, *Triangle Hill,* was written in 1956 by Qiao Yu, with its music composed by Liu Chi.

Triangle Hill recounts the most intense battle during the War to Resist US Aggression and Aid Korea. The song expresses the soldiers' heroism and sacrifice for their country. The lyrics and music present beautiful images of China's spectacular scenery. The first part of the song is led by a lyrical soprano with endlessly waving nostalgia steeping in the gentle and beautiful melody. The three stanzas seem to depict three paintings of beautiful sceneries of floating sails along rivers and rice paddies in fields. The rest of the song is refrain. The soprano, Guo Lanying, performed the first part of the song and its appeal has not waned for over half a century.

Qiao Yu, China's distinguished song lyricist, was born in Jining, Shandong Province in 1927. The movie script of *Liu Sanjie*, that of *Children in Revolutionary Years*, and the lyrics of "My Motherland", that of "Song of Peony", as well as the lyrics of "Shanxi Is a Good Place of Beautiful Scenery" and of "Let's Row with a Pair of Oars" are his masterpieces well known throughout the country.

Born in Xi'an Shaanxi Province, Liu Chi (1921–1998) has been drawn to music since his childhood and learnt to read notations and

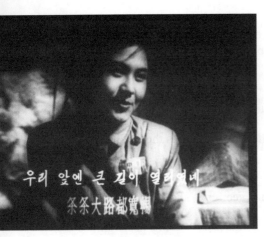

间艺人学习鼓乐、读谱、吹笙、吹笛、敲云锣，成了一名优秀的演奏员，为其以后的音乐创作打下了坚实的民族音乐基础。1939年，刘炽进入延安鲁迅艺术学院学习，师从冼星海学习作曲和指挥，毕业后进入音乐研究室当研究生兼助教。刘炽的创作生涯从1939年发表处女作《陕北情歌》开始，其作品数量之多、质量之高、流传之久远，在当代音乐家中实属罕见。

歌词：

（领唱）一条大河波浪宽，
　　　　风吹稻花香两岸，
　　　　我家就在岸上住，
　　　　听惯了艄公的号子，
　　　　看惯了船上的白帆。

（合唱）这是美丽的祖国，
　　　　是我生长的地方，
　　　　在这片辽阔的土地上，
　　　　到处都有明媚的风光。

（领唱）姑娘好像花儿一样，
　　　　小伙儿心胸多宽广，
　　　　为了开辟新天地，

play many traditional musical instruments from folk musicians. He became proficient in playing the drum, *sheng*, flute, and *gong*. This experience laid a solid foundation for his music career later. In 1939 he was admitted to Luxun Art Academy in Yan'an and studied composing and conducting under Xian Xinghai. After graduation, he worked as an assistant teacher and a post-graduate with the music teaching and research group. The publication of "Love Song of Northern Shaanxi" in 1939 started his compositional career. Few contemporary musicians can boast of the quality, quantity, and popularity of work generated throughout a career as can Liu Chi.

Lyrics:

(Leading singer) There is a great river, waves on waves,

The wind carries the aroma of rice flowers to both banks.

There lives my family at the riverside,

I'm accustomed to the boatmen's songs,

And watching those white sails.

(Chorus) This is my beautiful motherland,

A place where I was born;

On this vast expanse of land,

Enchanting sceneries are everywhere.

(Leading singer) The lasses have flower-like faces,

And the lads have ocean-like minds,

In order to open up a new world,

中国名歌选萃
三、20世纪创作的歌曲（15首）

唤醒了沉睡的高山，

让那河流改变了模样。

（合唱）这是英雄的祖国，

是我生长的地方，

在这片古老的土地上，

到处都有青春的力量。

（领唱）好山好水好地方，

条条大路都宽敞，

朋友来了有好酒，

若是那豺狼来了，

迎接它的有猎枪。

（合唱）这是强大的祖国，

是我生长的地方，

在这片温暖的土地上，

到处都有和平的阳光。

They awake the sleeping mountains,

And have rivers take on new looks.

(Chorus) This is my heroic motherland,

A place where I grew up,

On this ancient land,

The power of youth is all around.

(Leading singer)Beautiful mountains and waters make a delightful place,

And every road is so smooth and wide,

When our friends come, good wine welcomes them,

When our enemies come, shotguns welcome them.

(Chorus) This is my powerful motherland,

A place where I live my life,

On this warm land,

Everywhere is the sunshine of peace.

乔 羽
Qiao Yu

让我们荡起双桨 ㉒ Let's Row with a Pair of Oars

扫码欣赏
Scan the code to appreciate

乔羽词　刘炽曲
Lyrics by Qiao Yu, music by Liu Chi

三、20世纪创作的歌曲（15首）

旋律优美、节奏轻快的《让我们荡起双桨》是中华人民共和国成立后的第一部儿童影片《祖国的花朵》的主题歌，这部电影由长春电影制片厂在1955年摄制。

1955年夏天，为了让小演员们熟悉拍摄的环境和划船的动作，摄制组全体成员和小演员们来到颐和园，在昆明湖上划船。孩子们一边划船，一边打水仗，玩得很开心，他们活泼可爱的神态感染了刘炽。他开始和孩子们一起玩，并脱下鞋坐着船舷上，船在水上漂，人在船中笑。当船快要划到十七孔桥边的铜牛附近时，刘炽脑海中突然涌现了一段旋律，他立刻告诉划船的小朋友："快靠岸，快靠岸！"三个孩子全用眼睛瞪着他说："刘炽叔叔怎么啦？""歌的旋律出来了，我得马上记下来！"他对孩子们说。在岸边，他只用20分钟就写完了《让我们荡起双桨》这首歌。电影公映后，这首优美轻快的儿童歌曲就传遍了全国。后来又被编入我国的中小学音乐教材，一直流传到21世纪。

Selected Well-known Chinese Songs
III. Songs Created in the 20th Century (Fifteen Pieces)

With beautiful melody and rhythm, "Let's Row with a Pair of Oars" is the theme song of the film *Flowers of the Motherland* which was produced by Changchun Film Studio in 1955. It was the first film for children of the People's Republic of China.

There is an anecdote about this song. In the summer of 1955, to help child actors and actresses be familiar with the shooting environment and learn how to row a boat, the shooting crew of the film accompanied them to row boats on the Kunming Lake of the Summer Palace. They were enjoying the activity and the water fights. Deeply touched by the joyous children, Liu Chi, the composer of the song, joined them. When the boat was approaching the Seventeen-Arch Bridge, a melody suddenly came to Liu. He shouted, "Quick, quick, row to the shore!" Surprised, the three children on the boat asked Liu, "Is there anything wrong?" "The melody of a song is in my mind. I must write it down at once!" Liu explained to them. On the shore, he wrote down the music of "Let's Row with a Pair of Oars" in 20 minutes. After the film came out, the song soon spread nationwide. Later it was selected to be one of the songs taught in music classes in China's elementary and secondary schools and has been a popular song ever since.

这首歌的歌词分三节，第一节描述少年儿童泛舟北海欣赏到的自然风光。清澈的湖水，美丽的白塔，绿树红墙，色彩鲜艳和谐，令孩子们陶醉。第二节抒发他们荡舟时的喜悦心情。置身景色迷人的北海公园，他们愉快歌唱，尽情欢笑。歌词用拟人的手法，表达出他们对幸福生活无比愉悦的真切感受，同时又充满童趣。第三节则由尽情欢乐中的孩子们提出"谁给我们安排下幸福的生活？"的问题，表达了少先队员对祖国、对人民真挚的感激之情。

《让我们荡起双桨》是采用单二部曲式写成的一首童声合唱，它之所以能够经久传唱，主要还是由于它具有优美的旋律和如画的意境。作曲家用富有动感的节奏贯穿全曲，起伏的旋律层层展开，将人引入小船荡漾、水波连绵的画境之中。歌曲第二乐段头两个乐句用舒展的节奏，形象地描绘了孩子们奋力划桨、轻舟向前的情景。最后则在第一乐段第一乐句的变化再现中结束，使歌曲首尾呼应，浑然一体。这首歌不长，但层次分明，素材集中，作曲家在旋律中虽然融入了许多民族音乐的元素，但同样适时地加入了少年儿童特有的活泼和朝气。

歌词：

让我们荡起双桨，

小船儿推开波浪，

海面倒映着美丽的白塔，

四周环绕着绿树红墙。

小船儿轻轻，飘荡在水中，

迎面吹来了凉爽的风。

Selected Well-known Chinese Songs

III. Songs Created in the 20th Century (Fifteen Pieces)

The song is made up of three paragraphs. The first paragraph describes the colourful and harmonious natural scenes of the children who are intoxicated with the crystal water, the beautiful white tower, the green trees, and the red walls while boating in Beihai Park, part of the Imperial Palace. The second paragraph expresses their happiness when singing merrily in Beihai Park. In the third paragraph, a question is raised by those happy children: Who gives us such a happy life? showing their recognition that the country provides happiness for them.

"Let's Row with a Pair of Oars" is a children's chorus written in the binary form. The reason for its popularity lies in its beautiful melody and artistic conception. A dynamic undulating rhythm pattern runs through the whole song as the boats float on the rippling lake. In the second paragraph, the slowly stretching rhythm of the first two sentences describes the scene of children struggling to row forward. The song ends with the last sentence of the first paragraph. Many folk song elements are retained and the unique vigor and vitality of children is properly added.

Lyrics:

Let's row with a pair of oars,

The little boat acrosses the waves.

The lake reflects the fair White Tower,

Around us are green trees and red walls.

The boat is floating easily and softly,

It's floating ahead in a pleasant breeze.

红领巾迎着太阳,

阳光洒在海面上,

水中鱼儿望着我们,

悄悄地听我们愉快歌唱。

小船儿轻轻,飘荡在水中,

迎面吹来了凉爽的风。

做完了一天的功课,

我们来尽情欢乐,

我问你亲爱的伙伴,

谁给我们安排下幸福的生活?

小船儿轻轻,飘荡在水中,

迎面吹来了凉爽的风。

Selected Well-known Chinese Songs
III. Songs Created in the 20th Century (Fifteen Pieces)

The red kerchiefs shine in the sunlight,

Reflected by the water of the lake,

Fish watches us stealthily,

How joyously we sing.

The boat is floating easily and softly,

It's going ahead in a pleasant breeze.

Having finished our assignment,

We come here to play.

My dear fellows, do you know

Who gives us such a happy life?

The boat is floating easily and softly,

It's going ahead in a pleasant breeze.

刘炽 1955 年和小演员在一起
In 1995, Liu Chi and child actors

我爱你，中国 ㉓ I Love You, China

扫码欣赏
Scan the code to appreciate

瞿琮词　郑秋枫曲
Lyrics by Qu Cong, music by Zheng Qiufeng

三、20世纪创作的歌曲（15首）

中华人民共和国成立后，侨务工作取得了很大成绩，但由于"左倾"思想的影响，在一段时间里，华侨的地位与作用并未得到充分的重视。"文革"期间，"海外关系"甚至被视为"反动关系"。改革开放后，政策得到落实，许多华侨从海外回国参加祖国建设，在这样的时代背景下，1980年拍摄了一部反映爱国华侨心系祖国的电影《海外赤子》，《我爱你，中国》是这部电影的主题歌。

《海外赤子》是一部反映海外侨胞悲欢离合的故事影片，女青年黄思华报考部队文工团，虽然她的歌喉清脆婉转，但因是华侨的女儿，录取工作受到阻碍。"四人帮"被粉碎后，她才如愿以偿，登上了舞台。影片放映后，这首由著名女高音歌唱家、马来西亚归侨叶佩英教授演唱的主题歌便在中国广泛流传。1980年，《我爱你，中国》被评为"优秀群众歌曲"，1983年又获得第一届优秀歌曲评选"晨钟奖"。

歌曲由三部分构成。第一部分是引子性质的乐段，节奏较自由，气息宽广，音调明亮、高亢，旋律起伏跌宕，把人们引入百灵鸟凌空俯瞰大地而引吭高歌的艺术境界。第二部分是歌曲的主体部分，节奏较平缓，旋律逐层上升，委婉、深沉而又内在，铺展了一幅祖国大好河山的壮丽画卷，使"我爱你，中国"的主题思想不断深化。第三部分是结尾乐段，两个衬词"啊"的抒发，将歌曲引向最高潮。末尾句"我的母亲，我的祖国"在高音区结束，

Selected Well-known Chinese Songs
III. Songs Created in the 20th Century (Fifteen Pieces)

In the past thirty years, thanks to the open-door policy, many overseas Chinese returned to the homeland. In 1980 a movie called *Loyal Overseas Chinese* whose theme dealt with the lives of those who returned was shot. "I Love You, China" is the theme song of the movie.

Loyal Overseas Chinese tells us a story of joys and sorrows of overseas Chinese. The heroin Huang Sihua, daughter of an overseas Chinese, is good at singing. She takes an audition held by a music and dance ensemble of the Army. But her admission to the ensemble is hindered simply because she is from an overseas Chinese family. It was not until the smashing of the Gang of Four that her dream fulfilled. The distinguished soprano, Professor Ye Peiying of Central Conservatory of Music, a returned Malaysian Chinese, sang the theme song, which became widely known all around China. It was rated as one of the excellent mass songs in 1980 and won the Morning Bell Award at the first session of Voting for Excellent Songs in 1983.

The song is made up of three parts. The first part serving as the prelude with a comparatively freer rhythm, bright loud and sonorous tone and a melodically rising and falling tune leads listeners to an artistic state of the bird's-eye view of a lark flying high in the sky and singing happily in a loud voice. Euphemistic, profound and internalised, the second part being the main body of the song with a mild, placid rhythm and a gradually rising melody spreads out a

倾泻出海外儿女对祖国满腔炽烈的爱国主义情感，曲调起伏迂回，节奏自由悠长，与第一部分相呼应。

瞿琮（1944— ）
Qu Cong (1944-)

词作者瞿琮（1944— ），湖南长沙人，曾就读于武汉大学中文系，1965年任原广州军区专职作家。曲作者郑秋枫（1931— ），辽宁丹东人，曾就读于中南部队艺术学院，1957年开始从事音乐创作，曾在原广州军区战士歌舞团工作。

郑秋枫（1931— ）
Zheng Qiufeng (1931-)

歌词：

　　百灵鸟从蓝天飞过，

　　我爱你中国。

　　我爱你春天蓬勃的秧苗，

　　我爱你秋日金黄的硕果；

　　我爱你青松气质，

　　我爱你红梅品格；

　　我爱你家乡的甜蔗，

　　好像乳汁滋润着我的心窝。

Selected Well-known Chinese Songs

III. Songs Created in the 20th Century (Fifteen Pieces)

beautiful picture scroll of the magnificent scenery of the country, continuing to deepen the theme of "I Love You, China". Melody being ups and downs in circuity, rhythms being free and lengthy to echo well with the first part, the third part is the ending period, in which the padding syllable "ah" leads the song to its grand culmination. The last sentence "My motherland, my country!" ends at the upper register, pouring out the burning patriotism of overseas Chinese.

Qu Cong, who wrote lyrics of the song, was born in Changsha, Hunan Province in 1944. Graduated from the Chinese Language and Literature Department of Wuhan University, he became a professional writer at the Song and Dance Ensemble of Guangzhou Military Region in 1965. Zheng Qiufeng, who composed the song, was born in Dandong, Liaoning Province in 1931. Zheng once studied at the Art School of Mid-South China's Army Institute. He has started to compose since 1957 and once worked at the Song and Dance Ensemble of Guangzhou Military Region.

Lyrics:

The lark flies over the sky,

I love you, China!

I love you for flourishing shoots of rice in spring;

I love you for golden fruits on trees in autumn.

I love you for your qualities like the green pine;

I love you for your character like the red plum flowers.

I love you for sugar-canes of my home village;

Its sweet juice like milk gladdens my dry heart.

我爱你中国,

我要把最美的歌儿献给你,

我的母亲,我的祖国。

我爱你中国,

我爱你碧波滚滚的南海,

我爱你白雪飘飘的北国;

我爱你森林无边,

我爱你群山巍峨;

我爱你淙淙的小河,

荡着青波从我的梦中流过。

我爱你中国,

我要把美好的青春献给你,

我的母亲,我的祖国。

啊,我要把美好的青春献给你。

我的母亲,我的祖国。

Selected Well-known Chinese Songs
III. Songs Created in the 20th Century (Fifteen Pieces)

I love you, China!

I gift you with my best song,

My motherland, my country.

I love you, China!

I love you for blue waves swelling in the South Sea;

I love you for white snow swirling in the northern.

I love you for the boundless woods;

I love you for the high mountains.

I love you for the whispering of brooks;

Its blue waves flow in my sweet dreams.

I love you, China!

I gift you with my youth,

My motherland, my country!

Ah...

I gift you with my youth,

My motherland, my country.

叶佩英
Ye Peiying

美丽的草原我的家 ㉔ Beautiful Grassland My Home

扫码欣赏
Scan the code to appreciate

火华词　阿拉腾奥勒曲
Lyrics by Huohua, music by Alteng Aole

《美丽的草原我的家》作于1977年。1975年，诗人火华把他在内蒙古草原上的生活体验融入词作，写出了这首歌的歌词，蒙古族作曲家阿民布和将其谱成了一首女高音独唱歌曲，但没有流传开来。1977年，火华认识了阿拉腾奥勒，阿拉腾奥勒被这首歌词所感动，经过反复酝酿，重新为它谱了曲。

阿拉腾奥勒（1942—2011）
Alteng Aole (1942-2011)

火华（1942—　），诗人，北京人。1968年毕业于河北大学中文系，后在内蒙古军区从事文学创作。阿拉腾奥勒（1942—2011），蒙古族作曲家，内蒙古哲理木人，毕业于天津音乐学院，后来在内蒙古广播艺术团从事音乐创作，他的作品带有鲜明的蒙古族民间音乐的风格和时代气息，他曾创作过《乌力格尔主题随想曲》等优秀音乐作品，《美丽的草原我的家》是其代表作之一。

这首歌曲采用了蒙古族民间音乐的音调，并赋予它新的时代气息，曾在中华人民共和国成立30周年全国文艺调演中获得创作二等奖。1980年被联合国教科文组织以世界优秀歌曲选入教材，编入《亚太歌曲集》。这首歌的歌词如同一幅草原新生活的画卷，描绘了新时期牧民们安宁、舒适、如意的生活美景。音乐以内蒙古民歌的音调为素材，用柔美而又富有激情的旋律，抒发了牧民们对新生活的赞美之情。

全曲为单二部曲式。第一乐段的节奏稳健匀称，旋律线条以抛物线型为主，乐句和乐汇的高点都在其中间部分，犹如微风吹来，草原上绿草卷起波浪，将牧民内在的情感波涛和甜美的生活意境融合在曲调中。第二乐段副歌部分改为弱拍起唱，并用了四

The lyrics of *Beautiful Grassland My Home* were written in 1975 by Huohua, a poet. His lyrics reflect his experiences of living in the Inner Mongolian grassland. Alteng Aole, a composer, was moved by the lyrics and composed the music.

Born in Beijing in 1942, Huohua, (1942–), graduated from the Chinese Language and Literature Department of Hebei University in 1968 and then worked at the Ensemble of the Inner Mongolia Military Region, engaged in creative literary writing. The Mongolian composer, Alteng Aole (1942–2011), born in Zhelimu area, Inner Mongolia, graduated from Tianjin Conservatory of Music. He worked with the Inner Mongolia Broadcasting Art Ensemble and created many fine pieces in the Mongolian folksong style such as "Ulger Capriccio" and "Beautiful Grassland My Home", which are two of his masterpieces.

The adaptation of the tone of the Mongolian folk songs won it the second prize at the National Art Festival for the 30th anniversary of the founding of the People's Republic of China. In 1980, it was selected by UNESCO as one of the excellent songs worldwide, and was compiled into *Collections of Asia-Pacific Songs*. The lyrics are like an unfolded scroll painting depicting a life of peacefulness, comfort, and happiness on the Mongolian grassland.

The music is of the binary form with the cadence of the first paragraph firm and well proportioned. Its melodic contour is in the shape of parabola, the high point of the phrases being in the center top. This music form is like the breeze, gently rolling over wave after wave

度和八度的跳进，使旋律进行开阔而又挺秀，表现出蒙古族人民奔放、剽悍的民族性格。

歌词：

美丽的草原我的家，风吹绿草遍地花，
彩蝶纷飞百鸟儿唱，一弯碧水映晚霞。
骏马好似彩云朵，牛羊好似珍珠撒。
啊啊哈嗬咿
牧羊姑娘放声唱，愉快的歌声满天涯。

美丽的草原我的家，水清草美我爱它。
草原就像绿色的海，毡包就像白莲花。
牧民描绘幸福景，春光万里美如画。
啊啊哈嗬咿
牧羊姑娘放声唱，愉快的歌声满天涯。

of green grass to reflect the inner world of the nomads and their sweet lives. In the second paragraph, the refrain starts from a weak beat. The fourth and octave disjunctive motions expand the melody, straight forward and graceful, reflecting the unconstrained and courageous characteristics of the Mongolian people.

Lyrics:

On the beautiful grassland where my home is,

There are flowers everywhere and winds blow over the green grasses.

Birds are singing, butterflies dancing

By the crystal clear water reflecting the glow of the sunset.

Steeds run like colorful clouds,

Cattle and sheep like pearls are scattered all over.

Oh, a shepherd girl is singing her songs,

Songs float merrily in the air.

My home is on the beautiful grassland,

I love its serene waters and emerald grasses.

The steppe looks like the blue sea,

While the yurts are like white lotuses.

The nomads draw a picture of happiness,

Where warm sunshine of spring is everywhere.

Oh, a shepherd girl is singing her songs,

Songs float merrily in the air.

内蒙古草原
Inner Mongolia grassland

草原之夜 ㉕ A Night in the Prairie

扫码欣赏
Scan the code to appreciate

张加毅词　田歌曲
Lyrics by Zhang Jiayi, music by Tian Ge

中国名歌选萃

三、20世纪创作的歌曲（15首）

被人们誉为中国式小夜曲的《草原之夜》作于1955年，是纪录片《绿色的原野》中的一首插曲，这部纪录片反映了中国人民解放军新疆生产建设兵团战士们的生活。

词作者张加毅（1925— ），山西人，曾在延安鲁迅艺术学院学习，1947年参加中国人民解放军。中华人民共和国成立后在八一电影制片厂工作，1952年开始从事歌词创作，《草原之夜》是其代表作之一。

曲作者田歌（1931— ），山东人，也是部队培养的文艺人才。他1948年参加中国人民解放军，曾长期在新疆军区文工团工作。他善于把新疆各少数民族民歌的旋律因素和汉语语音相结合，其代表作有《草原之夜》《边疆处处赛江南》等。

这首歌的词曲作者在《绿色的原野》拍摄期间，曾随摄制组到新疆伊犁的军垦农场深入生活。一天傍晚，他们出去散步，听到一群维吾尔族青年战士在篝火旁深情地歌唱，深受感染，回到住地之后立即写成歌词，并根据当地维吾尔族民歌的音调，以徐缓、委婉的旋律创造了一种宁静、悠远的意境，抒发了在边疆垦荒的军垦战士对远方爱人的绵绵思念之情。这首歌写好之后，当晚就被唱给战士们听，从此，它就像一只美丽的夜莺，飞遍了我国的天南地北，成为人们喜爱的一首

Selected Well-known Chinese Songs
III. Songs Created in the 20th Century (Fifteen Pieces)

"A Night in the Prairie", created in 1955 and honored as a Chinese serenade, is the interlude of the documentary entitled *Green Fields* which is about the life of soldiers in Xinjiang Production and Construction Corps.

Born in Shanxi Province in 1925, the writer of the lyrics, Zhang Jiayi, studied at Luxun Art Academy of Yan'an. Since the founding of the People's Republic of China, he worked with Bayi Film Studio. He started to write lyrics in 1952. "A Night in the Prairie" is his magnum opus.

Born in Shandong Province in 1931, Tian Ge, the composer of the song, worked in the Song and Dance Ensemble in Xinjiang Military Region. He is a specialist in using ethnic folk tunes from Xinjiang and putting them to Chinese lyrics. His representative works include "A Night in the Prairie" and "Everywhere in Xinjiang Can Match Jiangnan".

Together with the film crew of *Green Fields*, Zhang Jiayi and Tian Ge went to an army reclamation farm in Yili, Xinjiang to get some first-hand experiences of living with the soldier farmers during the shooting of the film. One night while taking a walk together, they heard Uygur soldiers singing peacefully by a bonfire. They were deeply touched. By the time they returned from their walk, a new song was born. Based on the local Uygur folk song, they wrote the song, serene and peaceful of a slow and gentle melody, expressing the soldiers' yearning for their loved ones far away. The song was sung to the soldiers on the very night when it was written, and soon it became

抒情歌曲。

　　这首歌的前奏用同音反复开始，营造出草原之夜宁静的气氛，然后从高音区开始，蜿蜒下行，引出了从平稳的低音区开始的旋律。第二乐句从高音开始，舒张而悠扬，和第一乐句形成对比。第三乐句运用了中国民间音乐中常有的"腔音"，不仅达到了"字正腔圆"的效果，而且细致入微地刻画了战士们内心深处的情感。第三句的句末运用了维吾尔族民歌中常用的衬词"吔"，把第三、四两个乐句紧密地连在一起，也表达出一种渴望的情绪。第四乐句和第一乐句呼应，表现了军垦战士对美好未来的憧憬。尾声用了新疆哈萨克族民歌中富有特色的衬词"来"，速度加快，使节奏紧凑，给全曲增添了欢乐的气氛。

歌词：

　　　　美丽的夜色多沉静，
　　　　草原上只留下我的琴声，
　　　　想给远方的姑娘写封信吔，
　　　　可惜没有邮递员来传情。

　　　　等到千里冰雪消融，
　　　　等到那草原上送来春风，
　　　　可克达拉改变了模样吔，
　　　　姑娘就会来伴我的琴声。
　　　　来……
　　　　姑娘就会来伴我的琴声。

popular all over the country.

Starting with the same tone repeated in the prelude, the music creates a tranquil atmosphere of the night in the prairie. The singing melody begins to descend from the higher register, and then the melody moves to the steady lower register. Free and melodious, the second phrase starts from a high-pitched note contrasting with the first phrase. The glissando frequently used in Chinese, Turkic, and Mongol folk music, appears in the third line. The padding syllable "ye" which is often used in Uygur folk songs tightly connects the third and the fourth lines to express the desire for the lover. The padding syllable "lai" characteristic of Kazak folk songs in Xinjiang quickens the speeds and the rhythm, adding a happy atmosphere to the song.

Lyrics:

The beautiful night is so quiet,

There is only my music in the air,

I would like to write a letter to my girl far away,

There is no postman to deliver it.

I have to wait until the snow melts,

When spring breezes come to the prairie,

Kekedala grassland appearance will change.

The girl will come to accompany my music.

Lai...

The girl will come to accompany my music.

张加毅
Zhang Jiayi

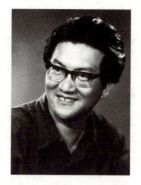

在希望的田野上 ㉖ In Promising Fields

扫码欣赏
Scan the code to appreciate

陈晓光词　施光南曲
Lyrics by Chen Xiaoguang, music by Shi Guangnan

三、20世纪创作的歌曲（15首）

《在希望的田野上》是同名纪录片的主题歌，作于1982年。20世纪80年代，改革的春风吹拂着中国大地，新的经济政策使中国农村发生了天翻地覆的变化，农民们正在为农业现代化奋斗，广大的农村一派兴旺发达的景象。这首中型合唱歌曲，通过对家乡充满希望的田野的描绘，抒发了对美好生活的赞美，歌颂了中国改革开放以后的新变化、新面貌，抒发了农民们对未来幸福生活的憧憬之情。

这首歌的歌词风格清新、朴实别致，具有浓厚的乡土气息。音乐采用领唱和合唱的形式，包括三个层次：第一层次曲调优美而流畅，以领唱为主，音乐明朗而抒情，唱出了家乡田野上的美丽景象；第二层次用类似汉族劳动号子一领众和的形式，将领唱和合唱结合起来，表现了一个热火朝天的劳动场面；第三层次以合唱为主，独唱女高音以花腔加以点缀，热情奔放，唱出了农村的新面貌和农民们对未来的希望。

词作家陈晓光（1948— ），河北人，1965年开始从事诗词创作，代表作有《那就是我》《在希望的田野上》等。

作曲家施光南（1940—1990），祖籍浙江，生于重庆。1964年毕业于天津音乐学院，先后在天津歌舞剧院和中央乐团任创作员。代表作有《祝酒歌》《在希望的田野上》《吐鲁番的葡萄熟了》《月光下的凤尾竹》等。

陈晓光（1948— ）
Chen Xiaoguang (1948—)

歌词：

我们的家乡在希望的田野上，
炊烟在新建的住房上飘荡，

Created in 1982, "In Promising Fields" is the theme song of a documentary with the same name. In the 1980s, great reform was carried out all over China with the new economic policies bringing radical changes to the country, prosperity everywhere in vast rural areas, motivating peasants to strive for the agricultural modernization. Being a medium chorus, "In Promising Fields" sings praise of people's happy life through depicting the promising lands with a new look after the reform and opening up and casts light on peasants' happy vision of their future.

Lyrics of the song are simple and unaffected in the phrasing with a rustic charm. The first stanza is presented mainly by a leading singer about the beautiful landscape of the fields. The second stanza resembles the Han work song, and the third stanza is sung primarily by the chorus, and decorated by the coloratura of the solo soprano.

Chen Xiaoguang, lyricist of the song, was born in Hebei Province in 1948. He started to write poetry in 1965. His representative works include "That Is Me" and "In Promising Fields".

Born in Chongqing, the composer Shi Guangnan (1940–1990) graduated from Tianjin Conservatory of Music in 1964. He worked with Tianjin Song and Dance Theatre and China Central Orchestra as a composer. "Toasting Song", "In Promising Fields", "Turpan Grapes Are Ripe", "Fernleaf Hedge Bamboo in Moonlights" are his masterpieces.

Lyrics:

Our promising fields lie in our native land,
Smoke floats over the new houses,

小河在美丽的村庄旁流淌。
一片冬麦，（那个）一片高粱，
十里（哟）荷塘，十里果香，
哎咳哟嗬呀儿咿儿哟
咳！我们世世代代在这田野上生活，
为她富裕，为她兴旺。

我们的理想在希望的田野上，
禾苗在农民的汗水里抽穗，
牛羊在牧人的笛声中成长。
西村纺花（那个）东港撒网，
北疆（哟）播种南国打场，
哎咳哟嗬呀儿咿儿哟
咳！我们世世代代在这田野上劳动，
为她打扮，为她梳妆。

我们的未来在希望的田野上，
人们在明媚的阳光下生活，
生活在人们的劳动中变样。
老人们举杯（那个）孩子们欢笑，
小伙儿（哟）弹琴姑娘歌唱，
哎咳哟嗬呀儿咿儿哟
咳！我们世世代代在这田野上奋斗，
为她幸福，为她增光！

III. Songs Created in the 20th Century (Fifteen Pieces)

Brooks flow by the beautiful village.

Winter wheat grows next to sorghum,

Ten miles of lotus ponds and ten miles of fragrant orchards,

Ah …

Generation after generation we live on the land,

For its richness, for its prosperity.

Our ideal lies in the promising land,

Rice sprouts in wake of the sweat of the farmer,

Cattle and sheep graze to the sound of the herdsman's flute.

In western villages cotton is sinned, from eastern ports net are cast,

Sowing on the northern frontier, threshing grain in the southern country,

Ah …

Generation after generation we labor on the soil,

For its beauty, for its adornment.

Our future lies in the promising fields,

People live in the bright sunshine,

Life improves because of their labor.

The old propose a toast while the young chortle,

Boys play the violin and girls sing a song,

Ah …

Generation after generation we work on the land,

For her happiness, for her glory.

施光南
Shi Guangnan

小城故事 ㉗ The Story of a Small Town

扫码欣赏
Scan the code to appreciate

庄奴词、翁清溪曲
Lyrics by Zhuang Nu, music by Weng Qingxi

三、20世纪创作的歌曲（15首）

庄奴（1921—2016）
Zhuang Nu (1921-2016)

《小城故事》是1979年拍摄的一部同名电影的主题歌。电影在以木雕闻名的台湾地区鹿港县三义镇拍摄，主题歌由庄奴作词、翁清溪作曲。

这首歌的歌词简洁明快，充满魅力，其旋律简朴平缓，五声音阶上下行的级进温婉清丽、典雅多情，具有浓郁的江南风格。电影上映后，这首歌曲很快在祖国各地流传开来。

庄奴（1921—2016），台湾著名词作家，有台湾词圣之称。他与大陆的乔羽、香港的黄沾并称"中国词坛三杰"。他一生写过三千多首歌词，《小城故事》《甜蜜蜜》《又见炊烟》《冬天里的一把火》等是他的代表作。

庄奴原名王景羲，1921年出生于北京，1943年为抗击日本侵略者，离开当时被日本占领的北京到四川参军，1949年到台湾，当过记者，后成为著名歌词作家。庄奴在台湾日夜思念故乡和亲人，曾数次从台湾回到大陆寻亲。最后终于在友人的帮助下，找到了失散多年的妹妹。他坐飞机回北京时，心情非常复杂。他写道："多少年没见了，家庭什么样子？老人还在不在？我给妹妹写信时说，见面是喜事，谁都不要哭，结果飞机一落地，回到了北京，我的眼泪就流下来了，然而，回家的感觉真好！"庄奴晚年回到大陆生活，2016年在重庆逝世。

Selected Well-known Chinese Songs
III. Songs Created in the 20th Century (Fifteen Pieces)

"The Story of a Small Town" is the theme song of a film with the same name filmed in 1979. The film was shot in Sanyi Town, Lugang County, Taiwan Province, which is famous for its wood carvings. The lyrics of the song is written by Zhuang Nu and the music is composed by Weng Qingxi.

The lyrics of this song are concise and charming. Its melody is simple and gentle. The pentatonic melody is progressive, gentle and beautiful, elegant and sentimental. It has a strong Jiangnan style. After the film was released, the song spread to every corner of China.

Zhuang Nu is a well-known lyric writer in Taiwan, known as the Sage of Lyrics in Taiwan. He is also known as "the three greatest poets in China" along with Qiao Yu in mainland China and Huang Zhan in Hong Kong. In his lifetime, he wrote more than 3,000 lyrics, such as "The Story of a Small Town", "Sweet", "See Smoke Again", "A Fire in the Winter" and so on.

Zhuang Nu is a pen name, and his real name is Wang Jingxi. He was born in Beijing in 1921 and in 1943, in order to fight against Japanese aggressors, he left Beijing occupied by Japan and joined Chinese army in Sichuan. He went to Taiwan in 1949, worked as a journalist, and later became a famous poet.

In Taiwan, Zhuang Nu missed his hometown and relatives day and night, and returned from Taiwan to the mainland China several times to seek relatives. Finally, with the help of some of his friends, he found his sister who he had lost touch for many years. When he flew back to Beijing, his mood was very complicated. He wrote that,

三、20世纪创作的歌曲（15首）

翁清溪（1936—2012），笔名汤尼，自幼颇有音乐天才，无师自通地学会了小提琴、黑管、萨克斯管、口琴、吉他、钢琴等多种乐器，23岁时便开始了演唱生涯，28岁组建乐队，36岁任台湾华视乐团团长兼指挥。翁清溪为了提高自己的音乐修养，曾经前后3次出国深造。第一次是到欧洲学习管弦乐配器法，第二次是到美国学习爵士乐，第三次又到美国进入南加州大学研读电影配乐的技法。

翁清溪一生创作过500首歌曲，数量多、质量高，因此获得过终身成就奖。他的作品温文儒雅、庄重平和，旋律如涓涓溪水，源远流长、清新隽永。其代表作除了《小城故事》外，还有《月亮代表我的心》《沙河悲歌》等。

歌词：

小城故事多，

Selected Well-known Chinese Songs
III. Songs Created in the 20th Century (Fifteen Pieces)

"How many years have I been missing? What's the family like? Is the old man still alive? When I wrote to my sister, I said that meeting was a happy event. No one should cry. As soon as the plane landed and returned to Beijing, my tears rolled down. However, it felt so good to go home!" Zhuang Nu returned to the mainland China in his later years and died in Chongqing in 2016.

Weng Qingxi (1936-2012), whose pen name is Tony, has a musical genius since childhood. He has learned violin, clarinet, saxophone, harmonica, guitar, piano and other musical instruments all by himself. He began his singing career at the age of 23. At the age of 28, he formed a band and at the age of 36 he was the head and conductor of China TV Orchestra in Taiwan. In order to improve his musical accomplishment, Weng Qingxi has gone abroad three times for further study. The first time was to study orchestration in Europe, the second time was to study jazz in the United States, and the third time was to study film music techniques at the University of Southern California in the US.

Weng Qingxi has created 500 songs in his life, which are of high quality. Therefore, he has won the Lifelong Achievement Award. His works are gentle and elegant, solemn and peaceful, with melodies like trickle streams, which have a faraway source and are fresh and meaningful. His representative works include "The Story of a Small Town" "The Moon Represents My Heart" and "An Elegy in the Dissert" and so on.

Lyrics:

The small town has so many stories

充满喜和乐，

若是你到小城来，

收获特别多。

看似一幅画，

听像一首歌，

人生境界真善美，

这里已包括。

谈的谈，说的说，

小城故事真不错。

请你的朋友一起来，

小城来做客。

Selected Well-known Chinese Songs
III. Songs Created in the 20th Century (Fifteen Pieces)

Full of joy and happiness

If you come to the town

There is a lot of harvest

If you look, it likes a picture

If you listen, it likes a song

Realm of life: truth, goodness and beauty

On the theory of conversation

The town story is really good

Invite your friends to come with you

Come to the small town to be a guest

翁清溪
Weng Qingxi

青藏高原 28 The Tibetan Plateau

扫码欣赏
Scan the code to appreciate

张千一词、曲
Lyrics and music by Zhang Qianyi

总面积为250万平方千米,平均海拔为4000～5000米的青藏高原不仅是中国最大的高原,也是世界平均海拔最高的地方,故有"世界屋脊"和"世界第三极"之称。青藏高原在中国境内的面积有240万平方千米,包括西藏自治区和青海省的全部、四川省西部、新疆维吾尔自治区南部,以及甘肃省、云南省的一部分。青藏高原河山壮丽,是长江和黄河的发源地,而且有灿烂辉煌的历史、鲜活的风土人情、神秘的宗教文化。《青藏高原》这首歌创作于1994年,是电视剧《天路》的片头主题歌。"天路"是"通天之路"的意思,指的是从青海省格尔木到西藏拉萨的青藏公路。剧中描写的是从20世纪50年代到90年代,为了修筑和维护这条公路,几代人奉献了青春年华的故事。这首歌不仅赞美了青藏高原,而且表达了追求"天人合一"意境的哲学理念。

出生于辽宁沈阳的朝鲜族作曲家张千一（1959— ）,毕业于沈阳音乐学院管弦系和上海音乐学院作曲系,主要作品有交响音画《北方深林》《A调弦乐四重奏》《嫂子颂》等。在创作这首歌的时候,张千一并没有到过青藏高原,但他熟悉藏族民歌,因此在创作过程中,吸收了藏族民歌的音调。

张千一（1959— ）
Zhang Qianyi(1959-)

Selected Well-known Chinese Songs
III. Songs Created in the 20th Century (Fifteen Pieces)

With a total area of 2.5 million square kilometers and an average altitude of 4,000 to 5,000 meters above the sea level, the Tibetan Plateau is not only the largest plateau in China but also the highest altitude in the world. It is thus called "the Roof of the World" and "the Third Pole of the Earth". The Tibetan Plateau inside the borders of China covers an area of 2.4 million square kilometers, including the Tibet Autonomous Region, Qinghai Province, the western part of Sichuan Province, the southern part of Xinjiang Uygur Autonomous Region as well as parts of Gansu and Yunnan provinces. Being the source of the Yangtze and Yellow Rivers, the Tibetan Plateau boasts magnificent natural scenery. The song "the Tibetan Plateau" was written in 1994 as the theme song for the TV series *The Road Skyward*. The title refers to the Qinghai-Tibet Highway from Golmud, Qinghai Province to Lhasa, Tibet. The series relate the story of people of several generations devoting their prime years to the construction and maintenance of the highway from the 1950s to the 1990s. The song was intended not only to praise the magnificence of the Tibetan Plateau, but also to express that people are an integral part of nature.

Born in Shenyang, Liaoning Province in 1959 and graduated from Orchestral Instrument Department of Shenyang Conservatory of Music and Composition Major of Shanghai Conservatory of Music, Zhang Qianyi, the writer of the song, is a Chinese Korean composer. His main works include the symphonic picture "The Northern Forest", "String Quartet in a Major" and "Ode to Sister-in-laws", etc. He hasn't been to the Tibetan Plateau then. Yet he was knowledgeable in Tibetan folk songs when he wrote the song, which enabled him to adopt the

三、20世纪创作的歌曲（15首）

全曲由一个纯四度和纯五度结合而构成的主导动机发展而来，采用单二部曲式。歌曲一开始就用衬词"呀拉索哎"展现了主导动机，旋律高亢嘹亮，具有藏族山歌的风格。接下来又用乐队奏出了主导动机，把听众带到了圣洁的雪域高原。第一乐段旋律起伏跌宕，但一直围绕着主导动机展开。第二乐段的节奏变得非常舒展，主导动机三次在不同的高度出现。旋律最后冲向最高音区，又从高音区下行，在一次跌宕起伏之后，圆满地结束。

歌词：

呀啦索哎……
是谁带来远古的呼唤？
是谁留下千年的祈盼？
难道说还有无言的歌，
还是那久久不能忘怀的眷恋。
哦，我看见一座座山，一座座山川，
一座座山川相连，
呀啦索
那就是青藏高原。

Selected Well-known Chinese Songs
III. Songs Created in the 20th Century (Fifteen Pieces)

tune of Tibetan folk songs in his work to create a sonorous, forthright and cheerful melody, fusing the sanctity of the heaven with people's praise of the plateau, making listeners feel purified and freed from mundaneness.

Adopting the binary form, the music of the whole song develops through a leitmotiv made up of a combination of the perfect 4th and the perfect 5th. Starting with the padding syllables "yalasoai" to reveal the leitmotiv of the song, the reverting and resonant melody features the style of Tibetan folk songs. Then to follow up, the leitmotiv played by the orchestra brings the listeners to the consecrated snow-covered plateau. Full of ups and downs, the melody of the first paragraph unfolds all the way around the leitmotiv while the rhythm of the second paragraph turns to smooth out with the leitmotiv appearing three times at different heights. Then the melody rushes at the highest register where it drops slowly. After another rising-up and falling-down it brings the song to a perfect ending.

Lyrics:

Yalasoai ...

Who is calling from the past long gone?

A prayer from ten thousand years ago?

It is a silent song,

A memory that lingers forever.

Ah, I see the mountains, the mountains

Linked with each other endlessly,

Yalaso

It is the Tibetan Plateau.

是谁日夜遥望着蓝天?

是谁渴望永久的梦幻?

难道说还有赞美的歌,

还是那仿佛不能改变的庄严。

哦,我看见一座座山,一座座山川,

一座座山川相连,

呀啦索

那就是青藏高原,

那就是青藏高原。

Selected Well-known Chinese Songs
III. Songs Created in the 20th Century (Fifteen Pieces)

Who gazes at an azure sky?

Or longs for everlasting reverie?

There is an anthem,

A never changing grandeur!

Ah, I see the mountains, the mountains

Linked with each other endlessly,

Yalaso

It is the Tibetan Plateau.

青藏高原
Qinghai-Tibetan Plateau

阿里山的姑娘 ㉙ Girls Living in the Alishan Mountain

扫码欣赏
Scan the code to appreciate

邓禹平词　张彻曲
Lyrics by Deng Yuping, music by Zhang Che

三、20世纪创作的歌曲（15首）

张彻（1924—2002）
Zhang Che (1924-2002)

《阿里山的姑娘》又名《高山青》，常常被人误以为是台湾少数民族的传统民歌，其实它只是一首应用台湾少数民族民歌的音调写成的创作歌曲。其作词者为邓禹平，作曲者是张彻。邓禹平（1926—1985），四川三台人，诗人、画家，1944年加入中央电影制片厂电影明星剧团任编剧和演员，1949年后在台湾从事文学创作，著有诗集《蓝色小夜曲》《我存在因为歌因为爱》等。张彻（1924—2002），原名张易扬，浙江青田人，著名电影编剧及导演，先在上海、台湾等地工作，后到香港并加入了邵氏公司，先后导演了《独臂刀》《报仇》《刺马》《洪拳小子》《洪拳与咏春》等数十部作品。

1947年，张彻率上海国泰电影公司摄制组到台湾拍摄电影《阿里山风云》，电影急需一首主题歌，张彻便让一同前去的邓禹平写歌词。邓禹平从来没去过阿里山，他回忆和女友白玫在家乡四川山水间嬉戏的场景才写出了这首歌的歌词，张彻在谱曲时采用了当地少数民族音乐的音调。这首歌具有鲜明的台湾少数民族民歌的风格，曲调欢快优美，既赞美了阿里山的秀丽山水，也唱出了台湾少数民族人民的民族自豪感。

邓禹平（1926—1985）
Deng Yuping (1926-1985)

Selected Well-known Chinese Songs

III. Songs Created in the 20th Century (Fifteen Pieces)

"Girls Living in the Alishan Mountain" is also known as "Green Mountains". It is a tune based on folk songs of Taiwan's ethnic minorities by Deng Yuping and Zhang Che. Deng Yuping (1926–1985), born in Santai, Sichuan Province, was a poet and painter. In 1944, he joined Central Film Studio as a scriptwriter and actor. Since 1949, he devoted himself to writing works of literature and published his collections of poems such as *Serenade in Blue* and *I Am Because of Song and Love*. Zhang Che (1924–2002) was born in Qingtian, Zhejiang Province. He was a well-known film scriptwriter and director and worked in places such as Shanghai and Taiwan. Eventually he went to Hong Kong and joined Shaw Brothers Film Studio. He directed such films as *One-armed Swordsman, Revenge, Dynasty of Blood, Disciples of Shaolin,* and *Shaolin Martial Arts*.

In 1947, Zhang Che led a camera crew of Shanghai Guotai Film Studio and went to Taiwan to shoot a film named *Stories of the Alishan Mountain*, which needed a theme song. Zhang Che asked Deng Yuping to write the lyrics. Deng had never been to Alishan, and he recalled the wonderful time he and his girlfriend spent among the mountains in his hometown of Sichuan and wrote the lyrics. When Zhang Che composed the melody, he used the tone of the local minority music. This song has a distinctive style of Taiwan minorities' folk songs, the melody is cheerful and graceful. It is not only to praise the beautiful view of the Alishan mountain, but also to sing the pride of Taiwanese ethnic minorities.

在电影拍摄过程中，人民解放军打过长江，1949年电影拍完时，摄制组已不可能返回祖国大陆，邓禹平便留在台湾，白玫则在家乡等他归来。直到1984年，邓禹平的同学、中国音乐学院教授罗忠榕才得知邓在台湾的消息，马上将它传达给在大陆终身未嫁还在等着邓的白玫，并将白玫演唱的《阿里山的姑娘》录音带托作家林海音女士转交给邓禹平。1985年，把自己痛悔一生的爱情悲剧深掩心底的邓禹平，在白玫的"姑娘和那少年永不分呀，碧水长围着青山转……"的歌声中逝世于台北。

20世纪60年代和70年代，由于这首歌是唯一以台湾少数民族音乐风格描述台湾山地风情和人物的歌曲，因此在当时的国语流行歌曲中独树一帜。由于歌词内容盛赞台湾少数民族，因此也是许多台湾少数民族歌手的保留节目。

《阿里山的姑娘》采用五声音阶羽调式，音乐结构非常完整，焕发出独特的光彩，唱出了人和自然融为一体的深厚感情，是一首具有台湾少数民族原生态民歌之美的气势磅礴的舞曲，表现了台湾山地同胞载歌载舞的情景。

Selected Well-known Chinese Songs
III. Songs Created in the 20th Century (Fifteen Pieces)

In the course of their making the film in Taiwan, the People's Liberation Army crossed the Yangzi River, which made it impossible for the film crew to return to mainland China when they finished shooting in 1949. So Deng Yuping had to stay in Taiwan while his girlfriend Bai Mei waited for him at her hometown. It was not until 1984 that Professor Luo Zhongrong from China Conservatory of Music, a classmate of Deng's learned that Deng Yuping was in Taiwan. He immediately told this to Bai Mei, who had been waiting for Deng almost all her life, remaining unmarried. Professor Luo also asked Ms. Lin Haiying, a writer, to take a tape to Deng, on which the song "Girls Living in the Alishan Mountain" sung by Bai Mei was recorded. In 1985, Deng Yuping, who had buried his life-long love tragedy deep in his heart, passed away in Taipei in the singing of the song by Bai Mei: The lad and the lass never be separated. The stream likes to move around the mountain forever.

As the only song describing the ethnic minorities and the landscape of Taiwan in the 1960s and 1970s, it is unique and outstanding among all Mandarin pop songs at that time. Since its lyrics speak of in glowing terms the ethnic minorities of Taiwan, it is kept in repertoires of many Taiwan singers of ethnic minorities.

The music of the song "Girls Living in the Alishan Mountain" uses the *yu* mode of the pentatonic scale with a complete music structure, which coruscates brilliantly in singing out an integration of man and nature, presenting the scene of local people's gala in the

三、20世纪创作的歌曲（15首）

歌词：

　　高山青，涧水蓝。

　　阿里山的姑娘美如水呀，阿里山的少年壮如山唉。

　　高山长青，涧水长蓝。

　　姑娘和那少年永不分呀，碧水常围着青山转唉。

Selected Well-known Chinese Songs
III. Songs Created in the 20th Century (Fifteen Pieces)

mountainous areas, making it a piece of dance music, momentous with the beauty of primitive music of ethnic minorities in Taiwan.

Lyrics:

 Ever so green is the Alishan Mountain,

 As muscular as its lad.

 Ever so blue is the Alishan's stream,

 As tender as its lass.

 The lad and the lass never be separated.

 The stream likes to move around the mountain forever.

阿里山的姑娘
A girl of the Alishan Mountain

走进新时代 ㉚ Entering a New Era

扫码欣赏
Scan the code to appreciate

蒋开儒词　印青曲
Lyrics by Jiang Kairu, music by Yin Qing

《走进新时代》作于1997年,是为迎接中国共产党第十五次全国代表大会的召开而创作的一首政治性很强的抒情歌曲,它抒发了中国人民在20世纪和21世纪之交的昂扬情怀,也是全民族发自肺腑的心声。

蒋开儒(1935—)
Jiang Kairu (1935-)

歌词作者蒋开儒(1935—),广西桂林人,从20世纪60年代开始习作小说、曲艺、戏剧,在80年代以后专攻歌词,主要作品有《喊一声北大荒》《春天的故事》《走进新时代》等。曲作者印青(1954—),上海人,1970年加入中国人民解放军从事文艺工作,1981年入上海音乐学院进修。代表作有歌曲《当兵的历史》《走向新时代》,歌剧《党的女儿》等。

《走进新时代》的歌词用凝练的文学语言,概括了全国人民走过的光辉历程,表达了全国人民向新世纪进发,开创未来的心声。这首歌的歌词有别于那种直白的口号式的空洞说教,也有别于某些浅显的表白。"勤劳勇敢的中国人,意气风发走进新时代",

印青(1954—)
Yin Qing (1954-)

这两句歌词虽不新颖,但用在这里,则恰如其分地表现出了中华民族五千年的文明烙在华夏儿女身上的传统美德和中国人民"意气风发"的精神风貌。

Selected Well-known Chinese Songs
III. Songs Created in the 20th Century (Fifteen Pieces)

"Entering a New Era" is a lyrical yet highly political song created in 1997 for the opening of the 15th National Congress of CPC, expressing high spirited aspiration of Chinese people at the new millennium.

Born in Guilin, Guangxi Province in 1935, Jiang Kairu, the writer of the lyrics of the song, took up writing fictions, works of folk art forms and plays since the 1960s. From the 1980s, he began to devote himself to lyrics writing. His main works include "Oh, My Great Northern Wilderness" "The Story of Spring", and "Entering a New Era", etc. Yin Qing, the composer of the song, was born in Shanghai in 1954. In 1970, Yin joined the Army as an art solider and furthered his study in composition at Shanghai Conservatory of Music in 1981. His major works are "My Days as a Solider", "Entering a New Era" and the opera "Daughter of the Party", etc.

Concise in its language of literature, different from the empty precept slogans or straightforward profession, the lyrics of the song summarize the glorious course of Chinese people and express their determination to march forward to the new era to create their future. "The valiant and industrious Chinese people are entering a new era, vigorous in high-spirits." Although there is nothing original and novel in this sentence, the traditional virtues imprinted on Chinese people by the civilization of five thousand years and their high spirits are appropriately expressed.

中国名歌选萃
三、20世纪创作的歌曲（15首）

这首歌的音乐追求一种平和、质朴、简洁的风格，旋律优美、朗朗上口。歌中以抒情的中国南方民间音乐的音调为主，亲切感人，加上节奏的流动性，形成奔腾向前的宏大气势，以领唱与合唱的形式抒发了我国人民对祖国和对一切美好事物的热爱，展现了中国人民建设社会主义现代化强国的决心和信念。

歌词：

总想对你表白，我的心情是多么豪迈，
总想对你倾诉，我对生活是多么热爱，
勤劳勇敢的中国人，意气风发走进新时代。
啊，我们意气风发走进那新时代。

我们唱着东方红，当家作主站起来，
我们讲着春天的故事，改革开放富起来，
继往开来的领路人，带领我们走进那新时代，
高举旗帜开创未来。

让我告诉世界，中国命运自己主宰，
让我告诉未来，中国进行着接力赛，
承前启后的领路人，
带领我们走进新时代。
啊，带领我们走进那新时代。

Selected Well-known Chinese Songs
III. Songs Created in the 20th Century (Fifteen Pieces)

Easy to sing, the music of the song follows a plain, simple and peaceful style with a beautiful melody. Primarily based on the lyrical tune of the Southern China folk songs which is cordial and moving, it gains momentum through the fluidity of its rhythm, galloping forward in chorus led by the leading singer, giving expression of Chinese people's love for a better world and letting off the belief and determination to make our country a modernized socialist power.

Lyrics:

I want to confess, how heroic I feel,

I really want to let you know, how much I love my life,

The valiant and industrious Chinese people are entering a new era, vigorous in high-spirits.

As we sing "The East Is Red",

Masters of our fate, we stand,

We sing the "Story of Spring",

Renewed, open, and prosperous.

The leaders lead us into a new era,

Hold high our banner to create the future.

Let me tell the world,

China is her own master, let me tell the future,

China is in a race, the leaders of the past,

Lead us into a new era.

Ah, lead us into a new era.

三、20世纪创作的歌曲（15首）

我们唱着《东方红》，

当家作主站起来，

我们讲着春天的故事，

改革开放富起来，

继往开来的领路人，

带领我们走进那新时代，

高举旗帜开创未来。

Selected Well-known Chinese Songs
III. Songs Created in the 20th Century (Fifteen Pieces)

As we sing "The East Is Red",

Masters of our fate, we stand,

We sing the "Story of Spring",

Renewed, open, and prosperous,

The leaders lead us into a new era,

Hold high our banner to create the future.